curtains
and
holes

pablo hare

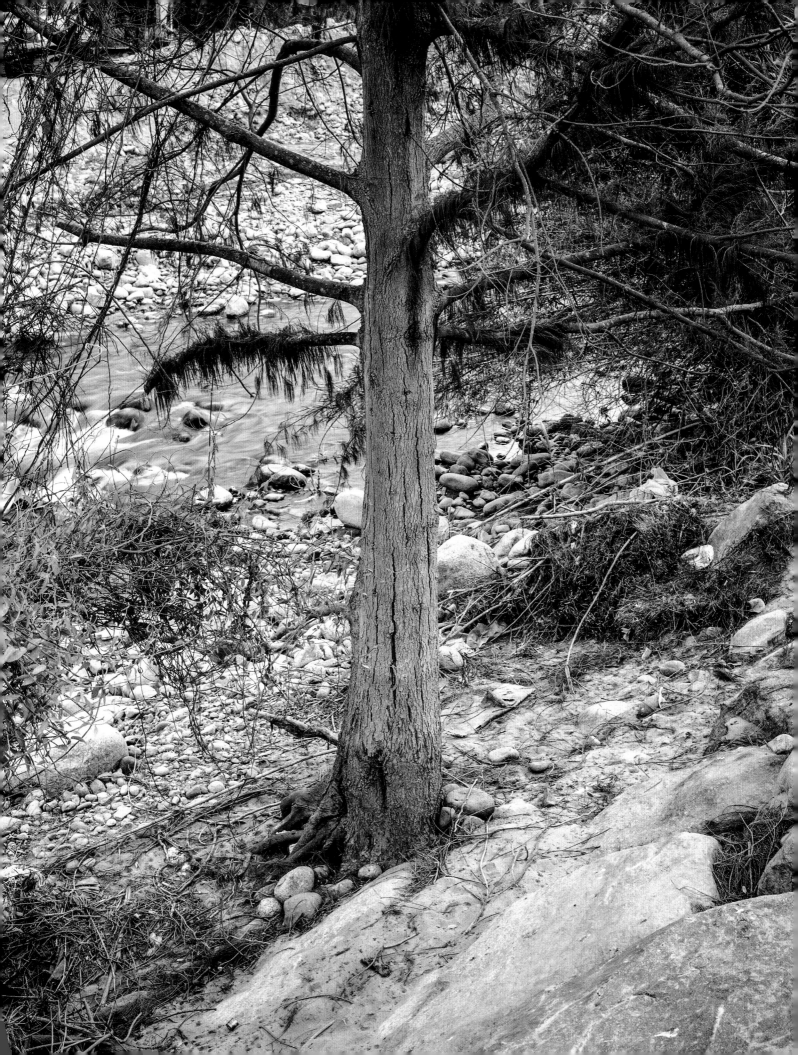

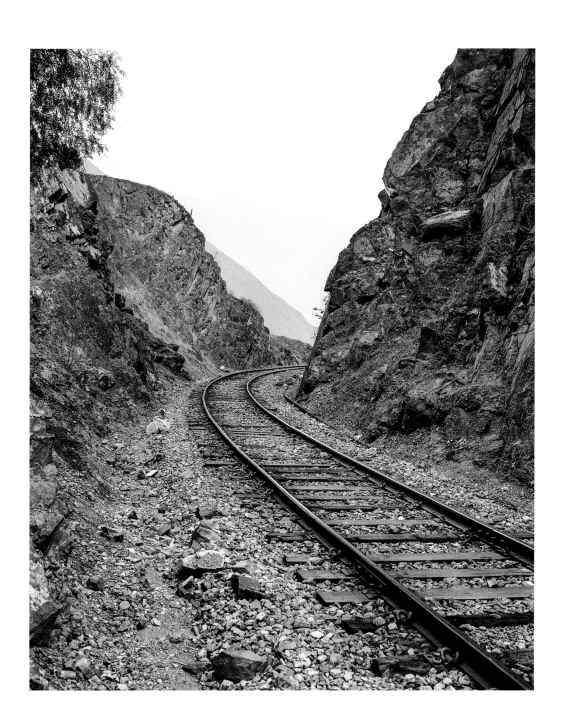

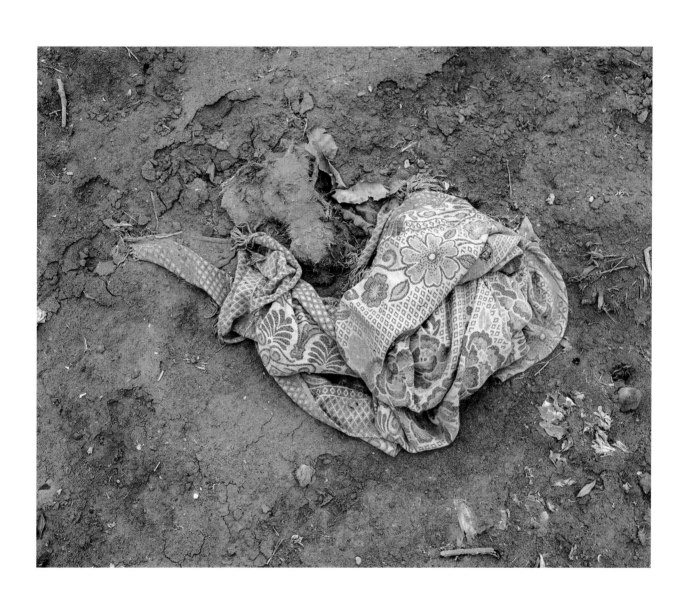

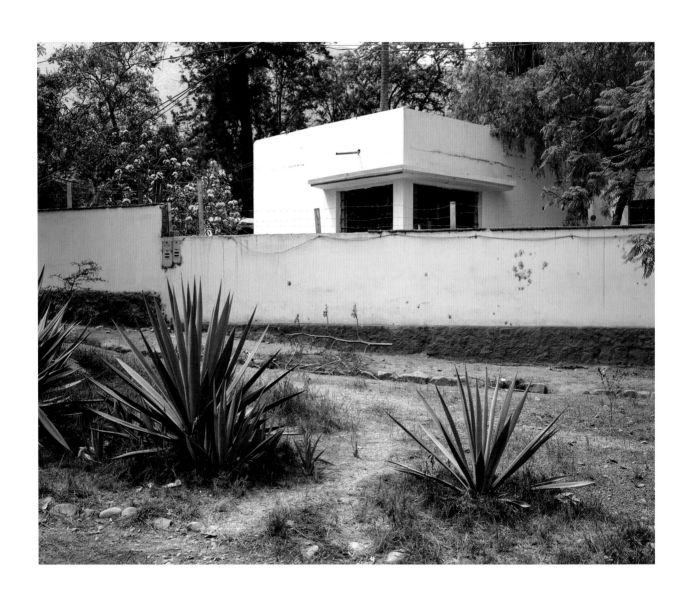

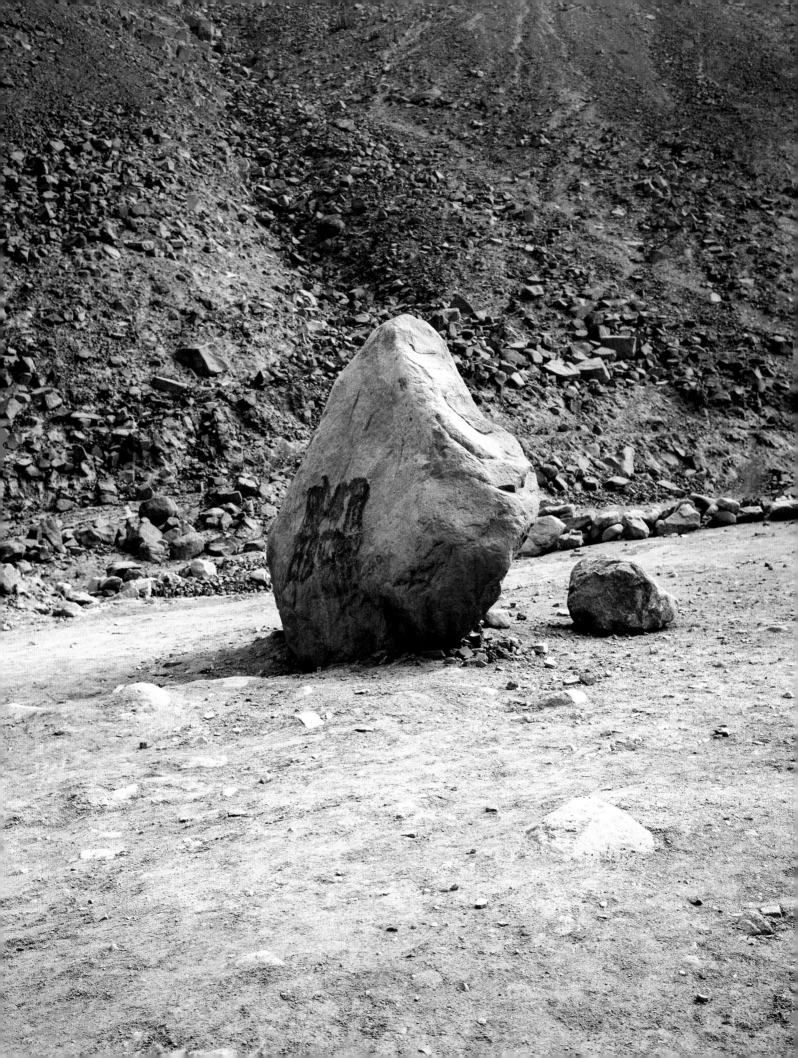

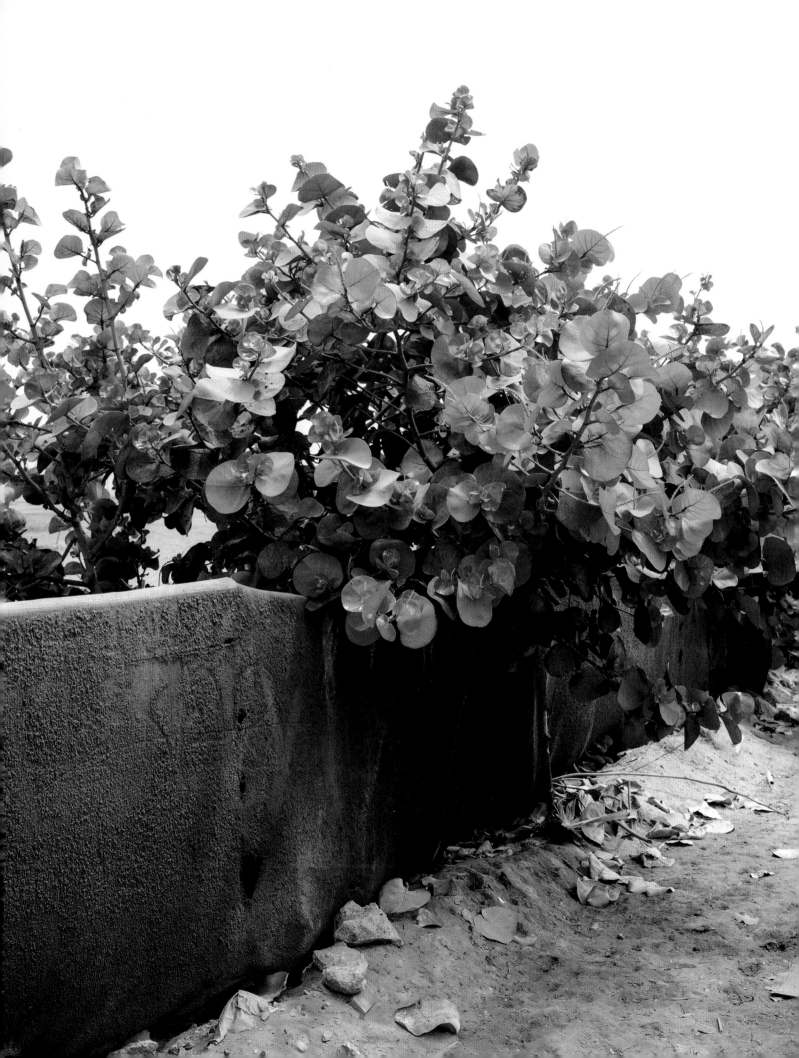

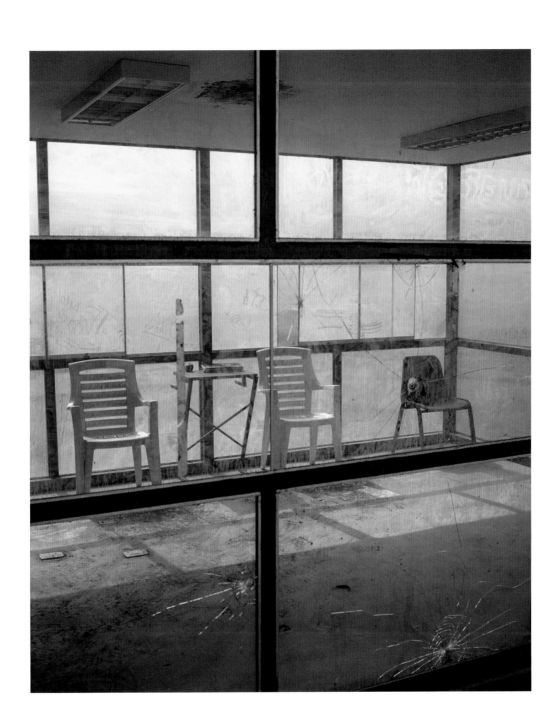

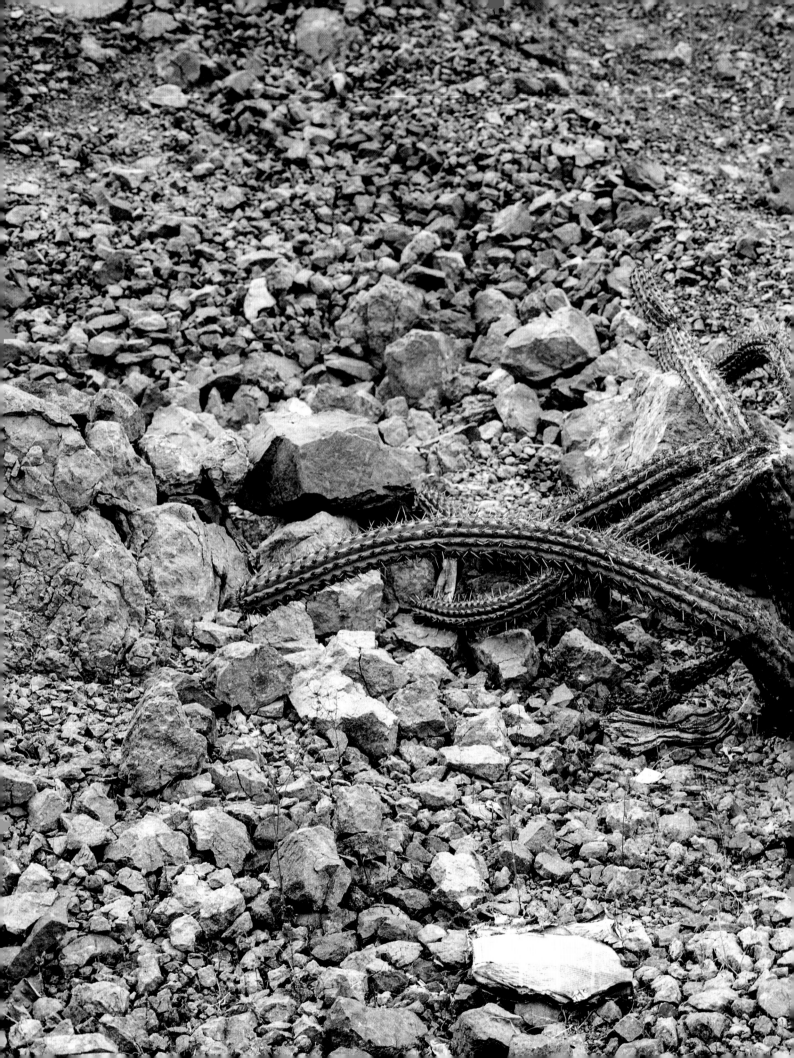

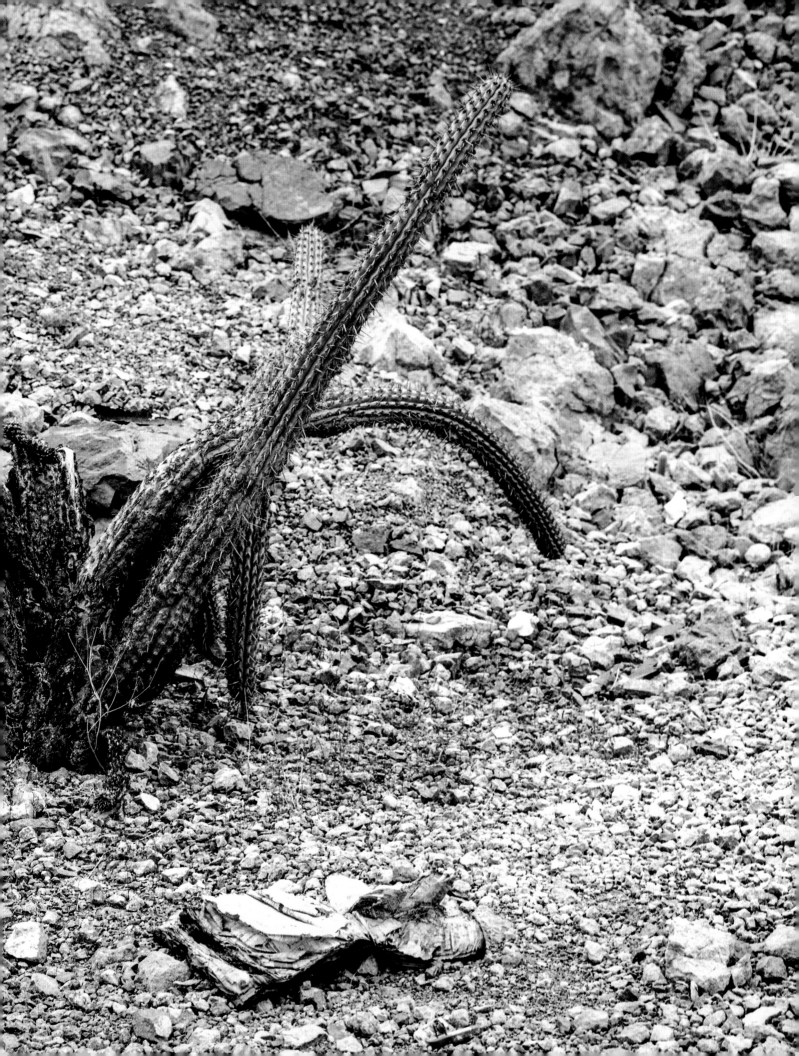

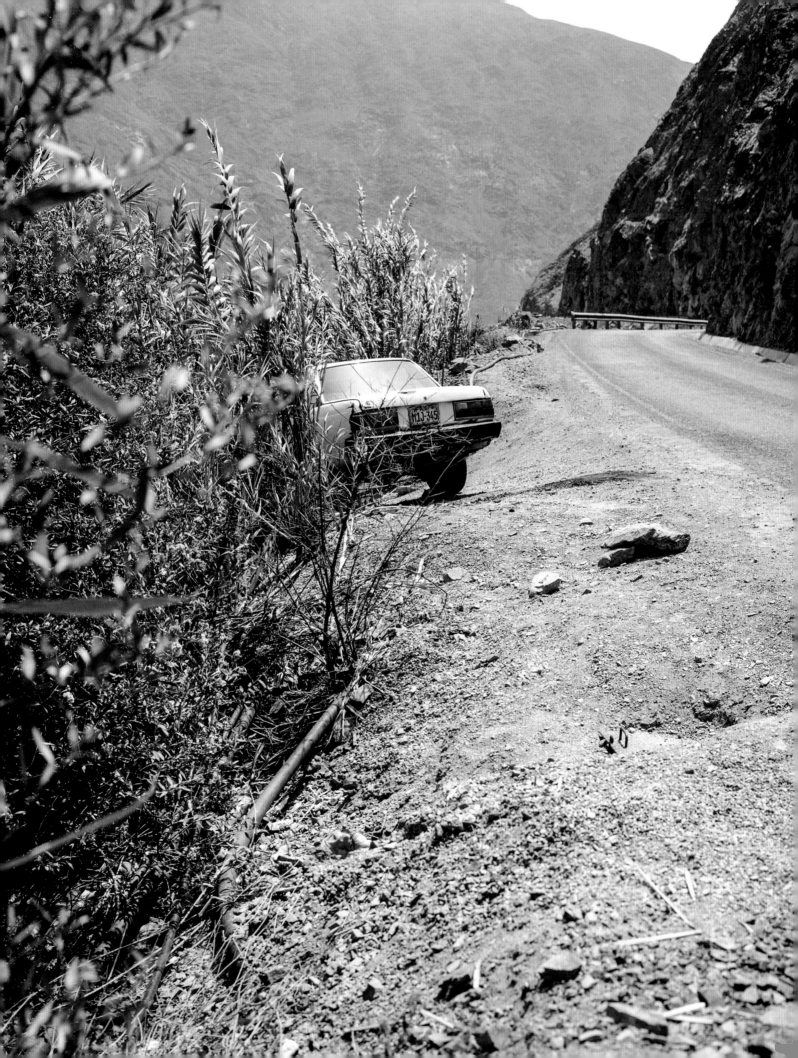

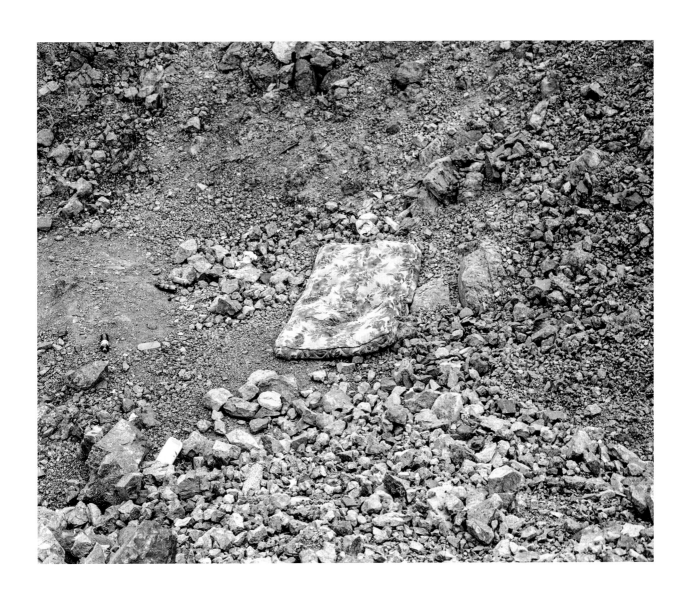

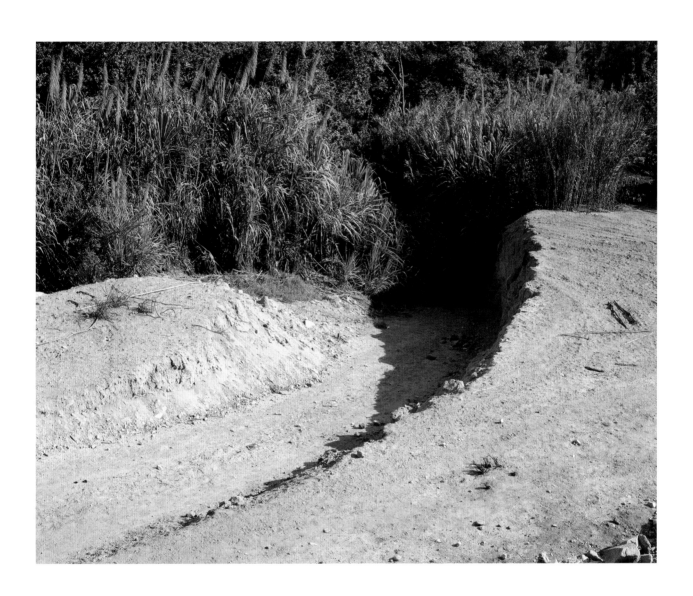

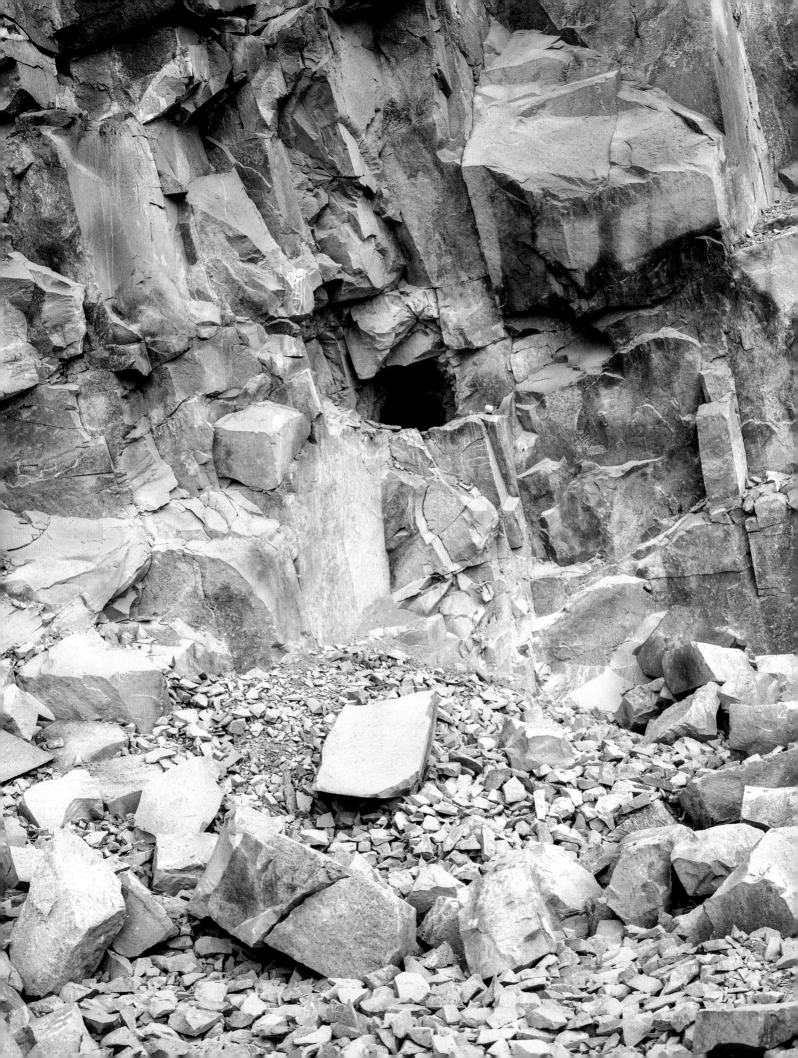

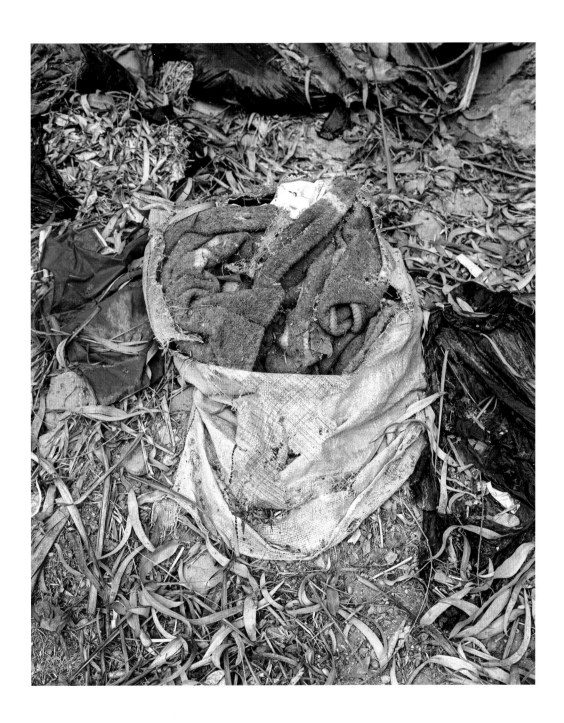

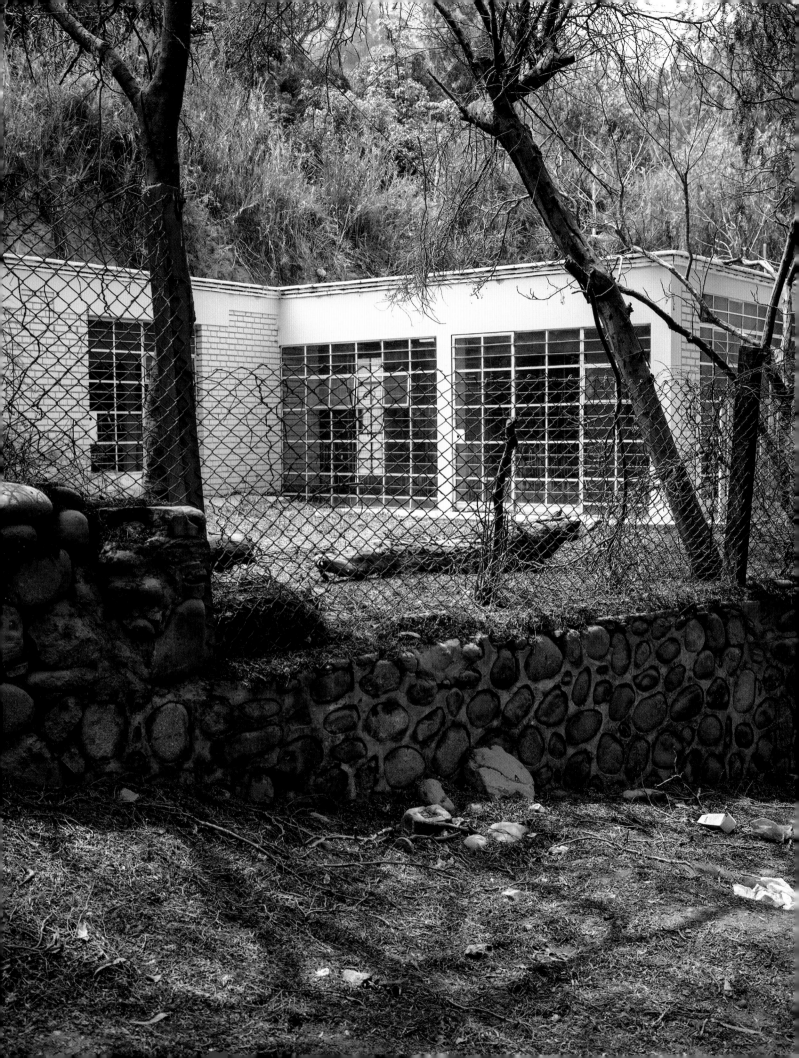

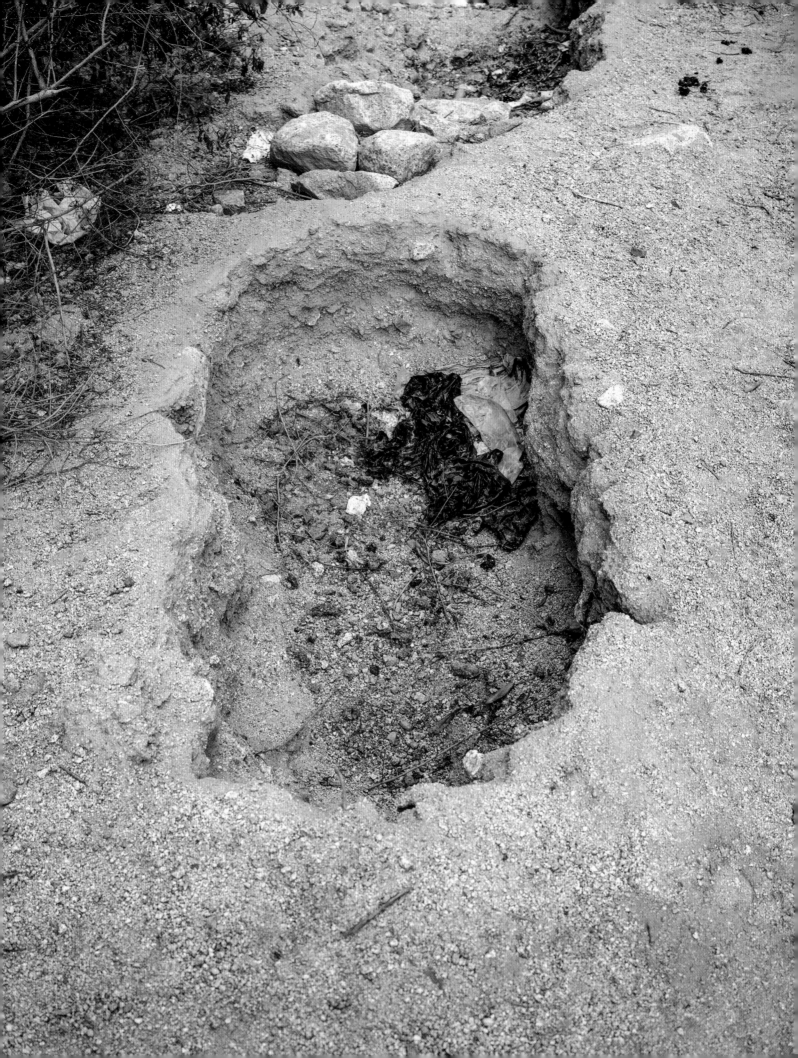

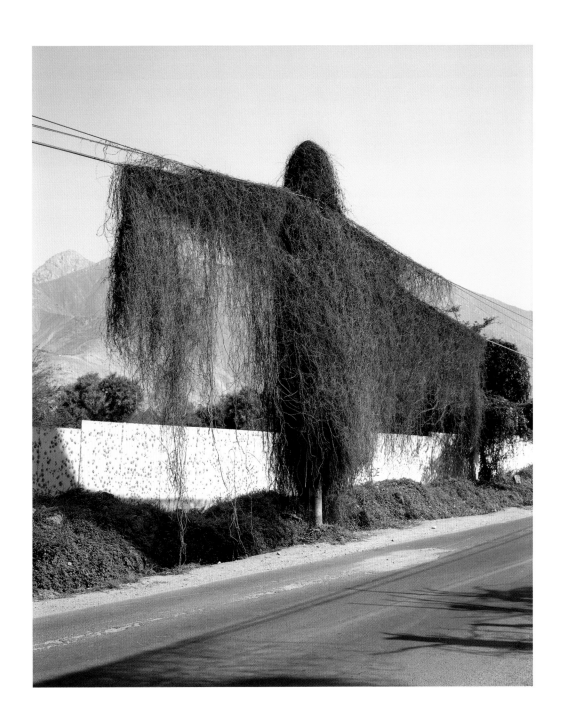

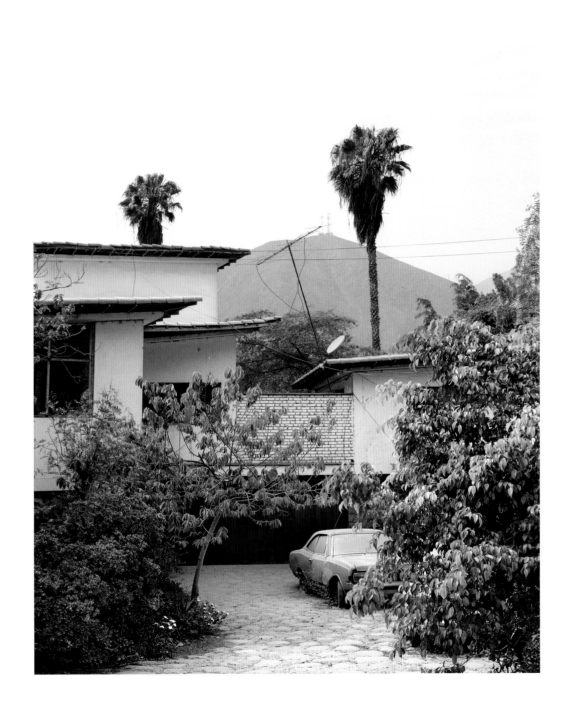

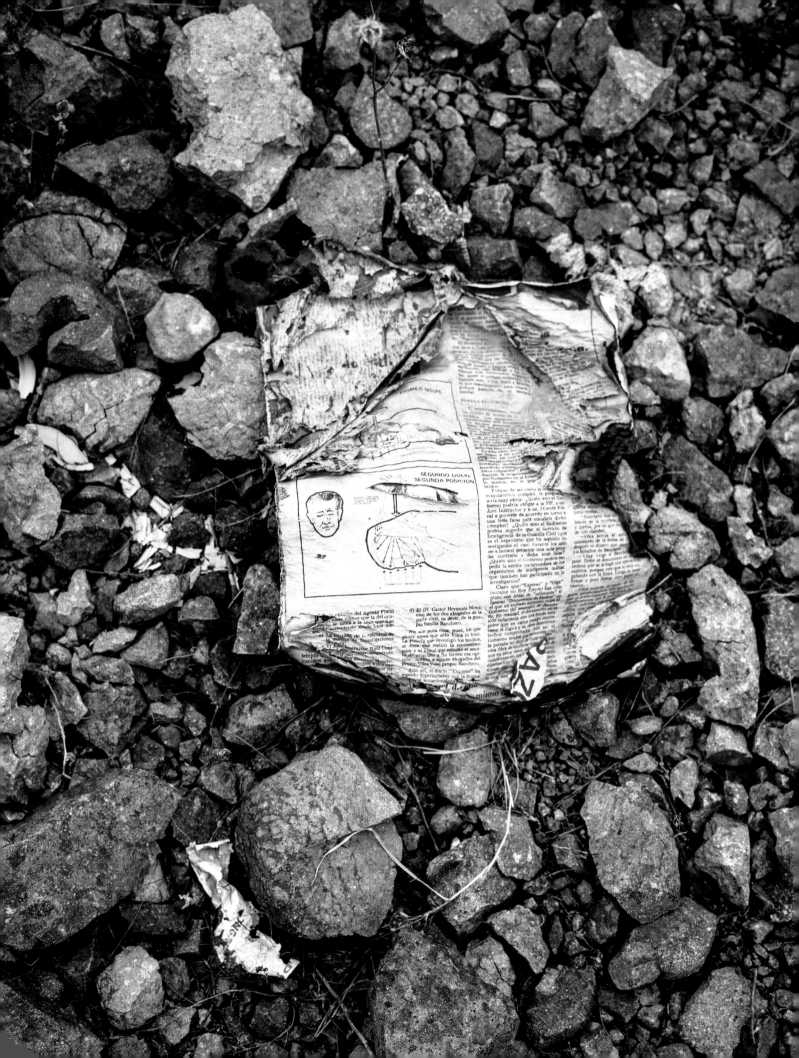

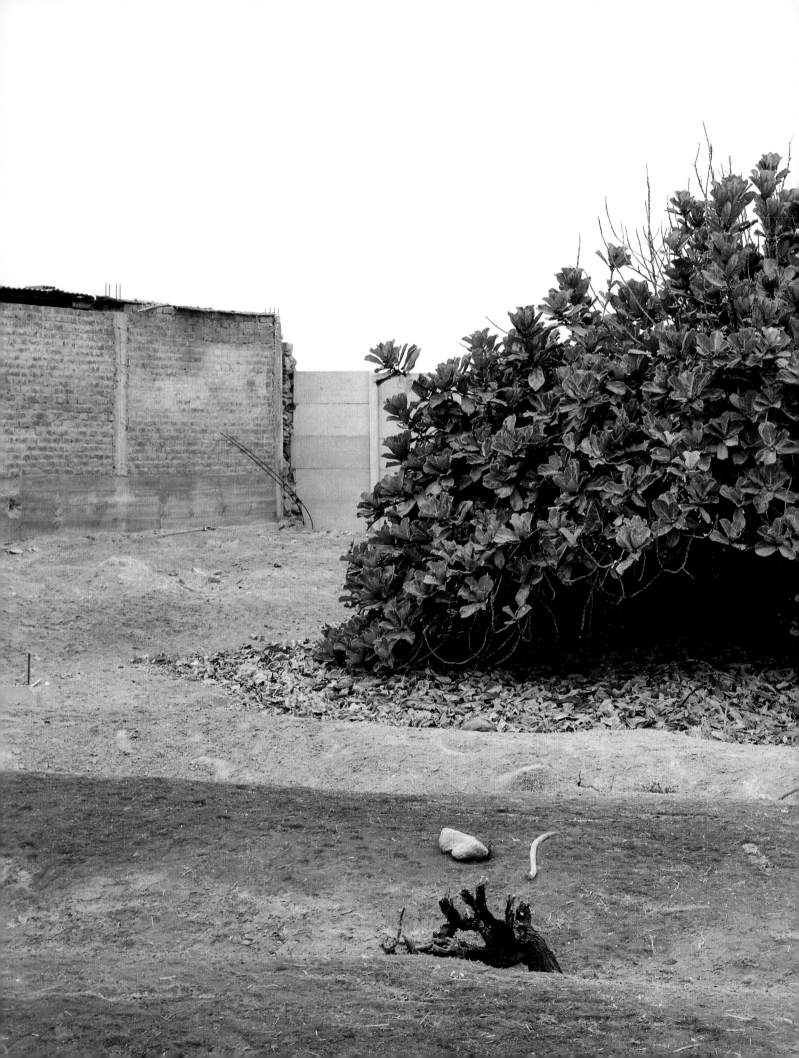

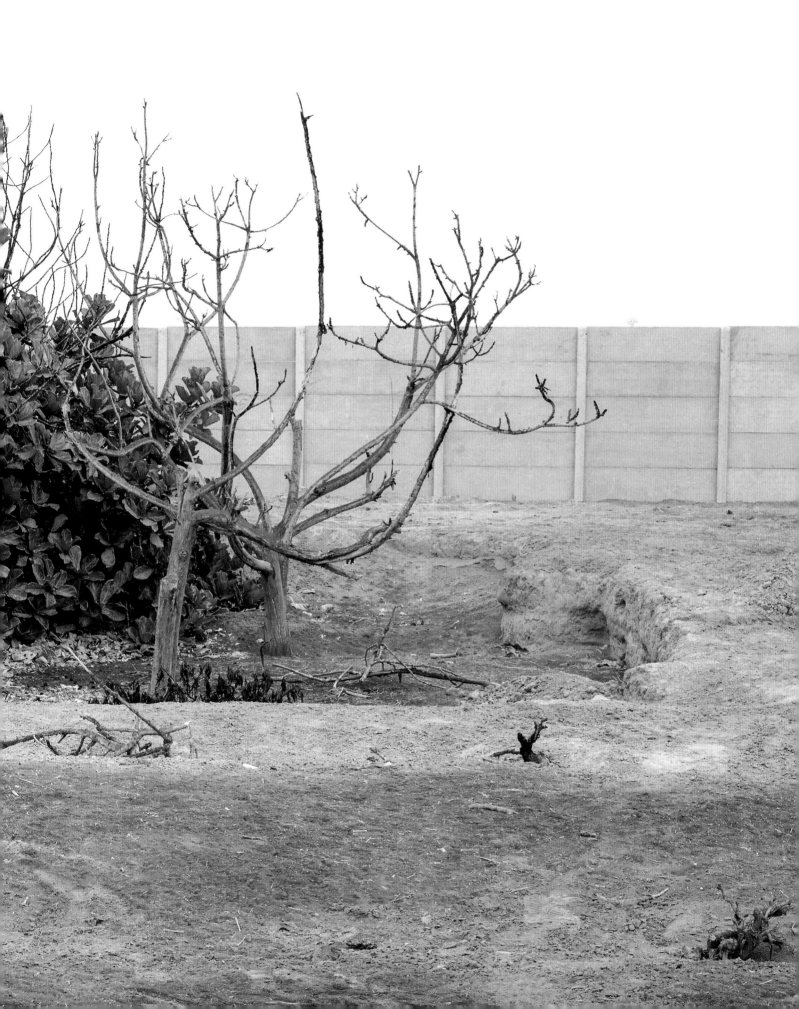

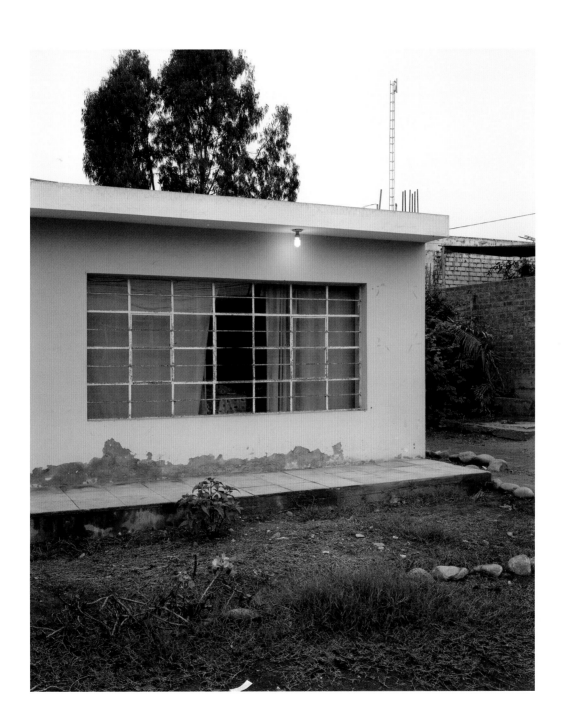

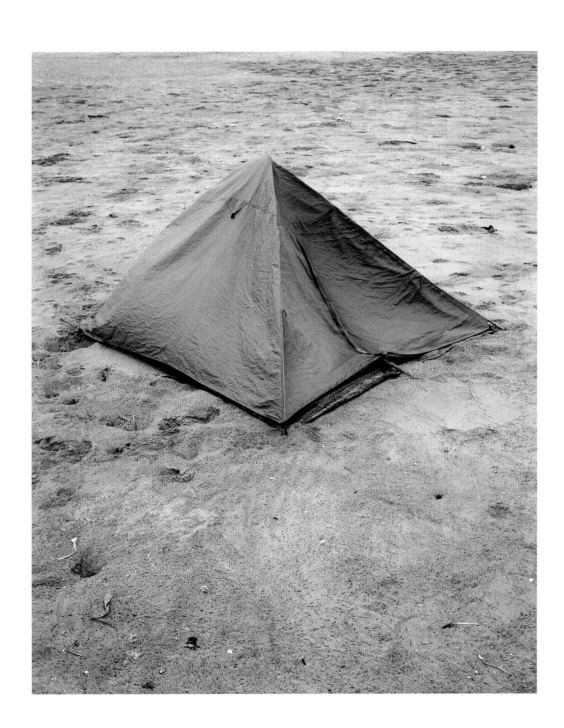

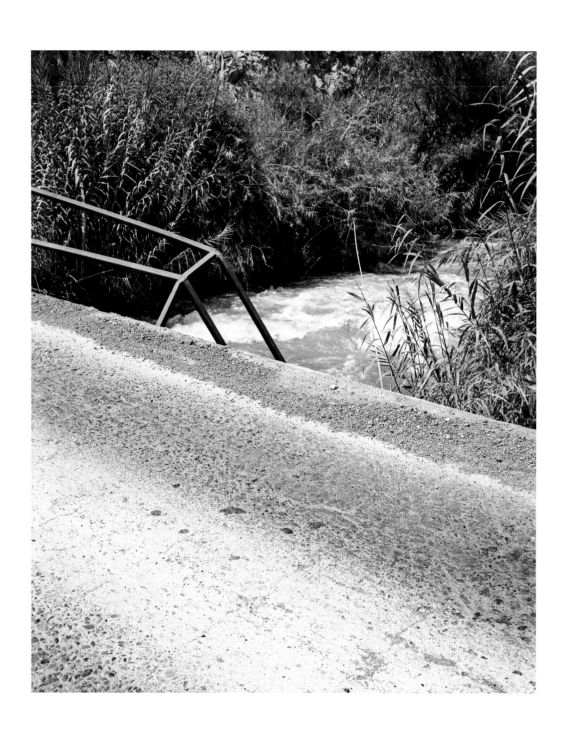

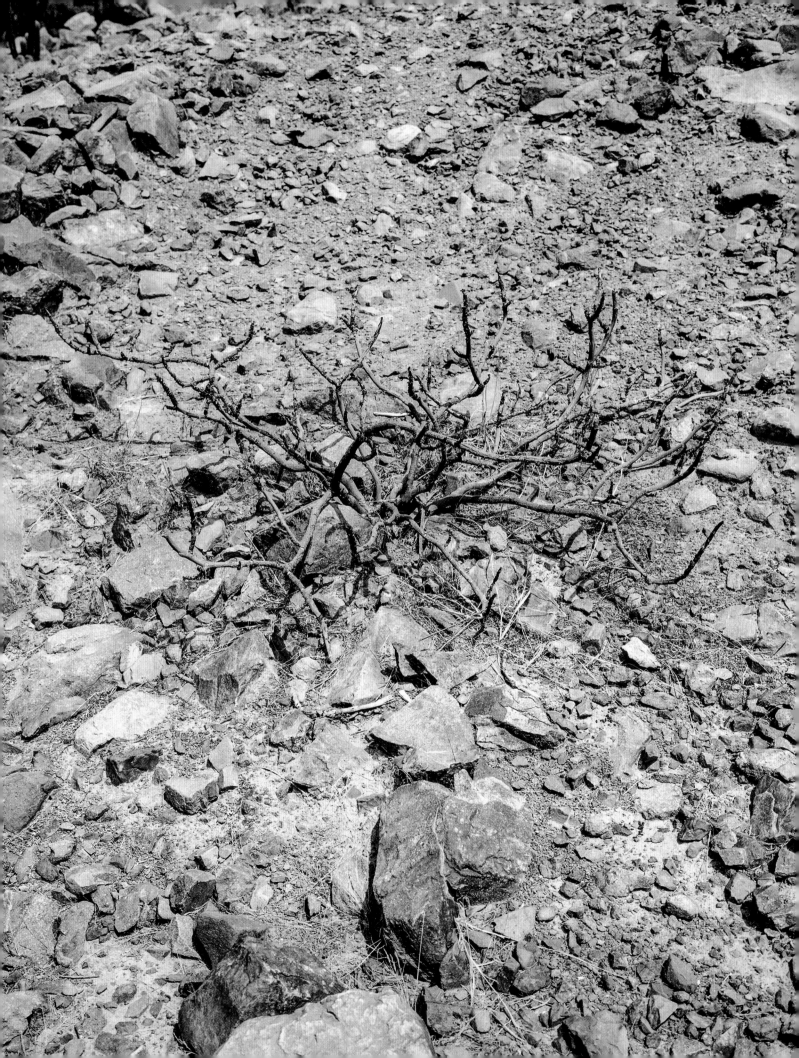

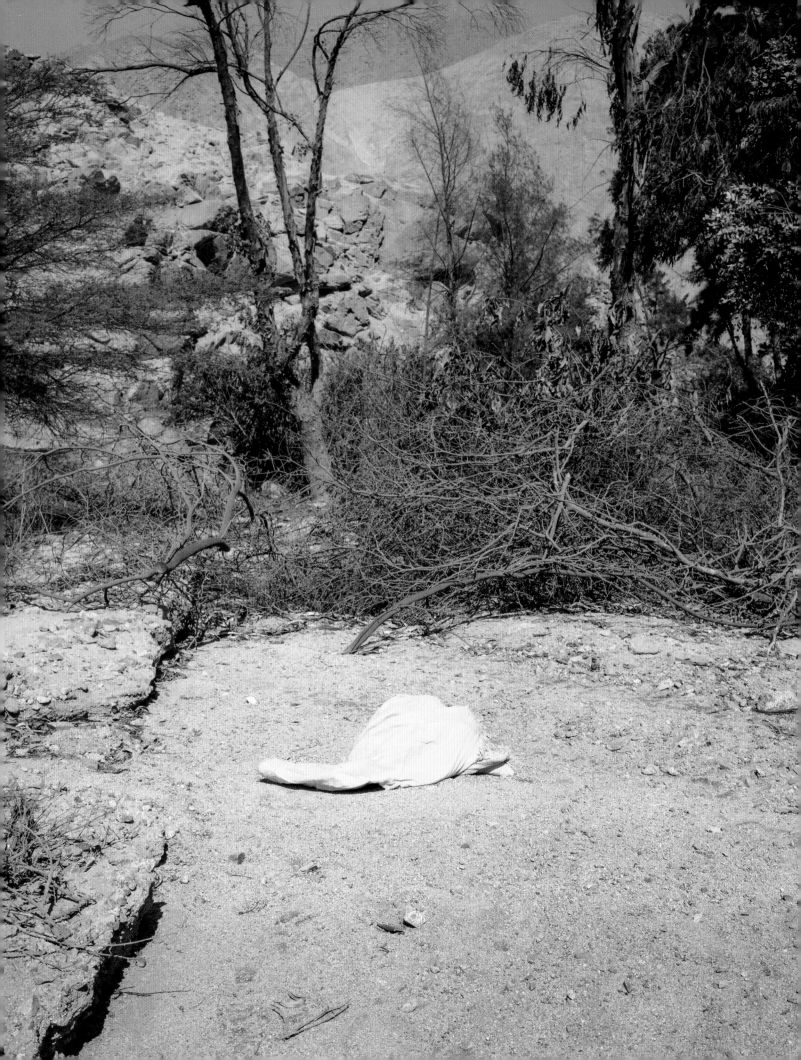

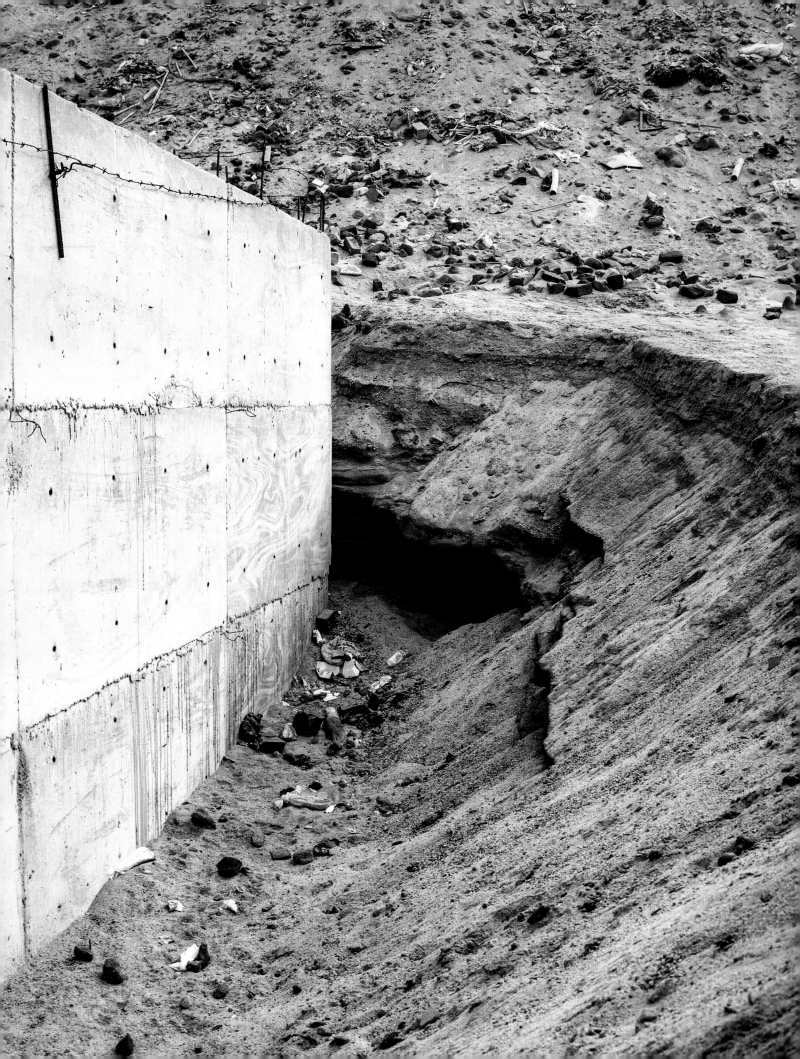

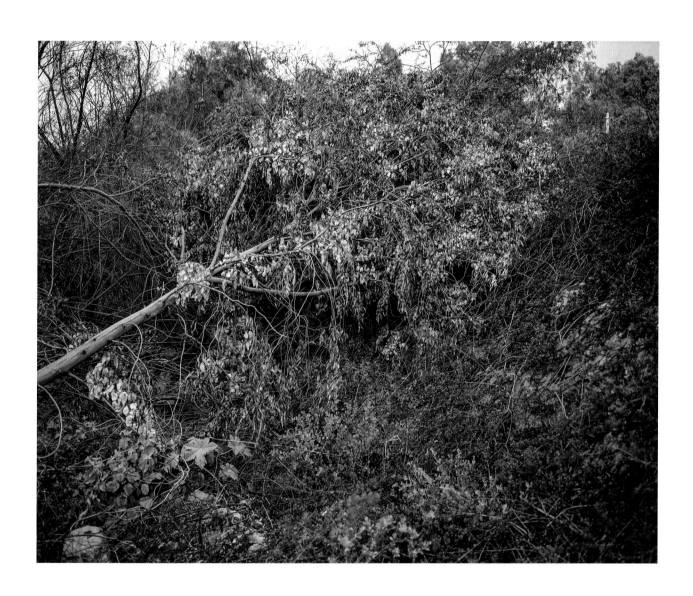

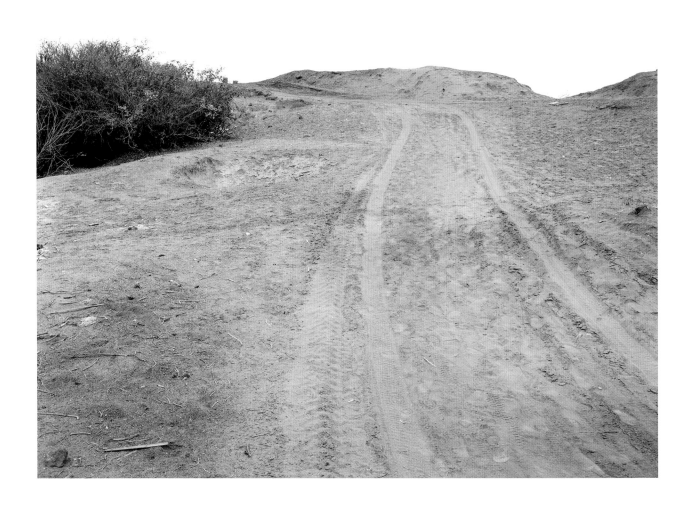

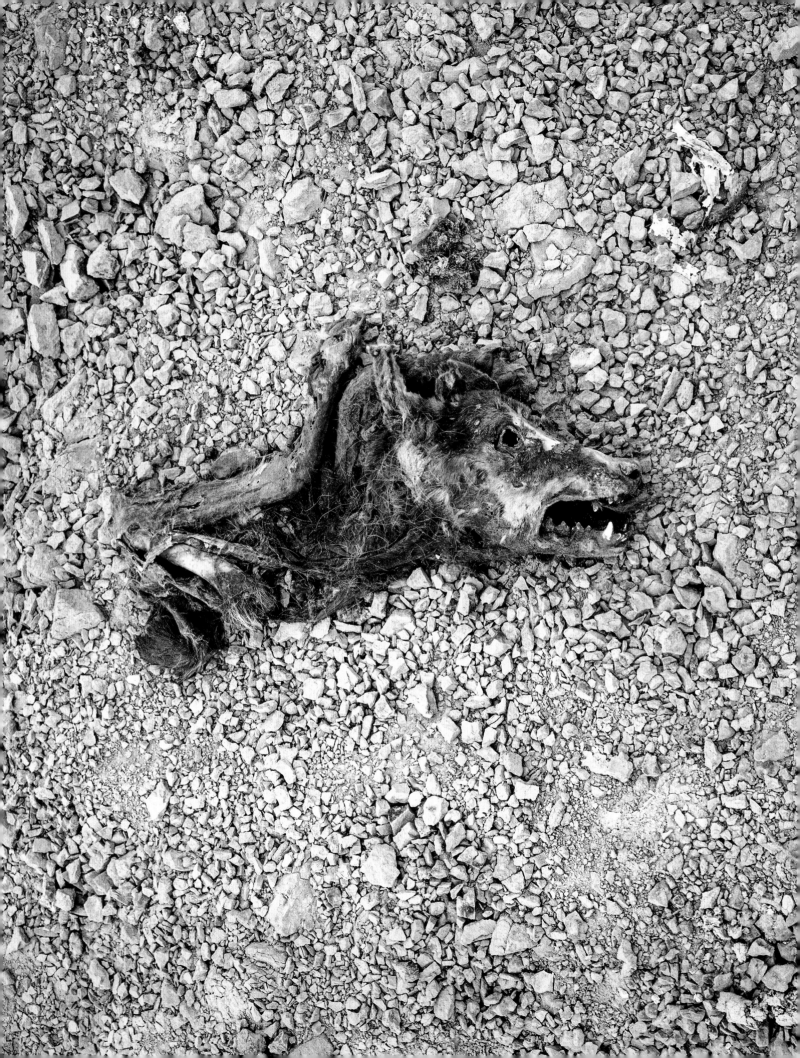

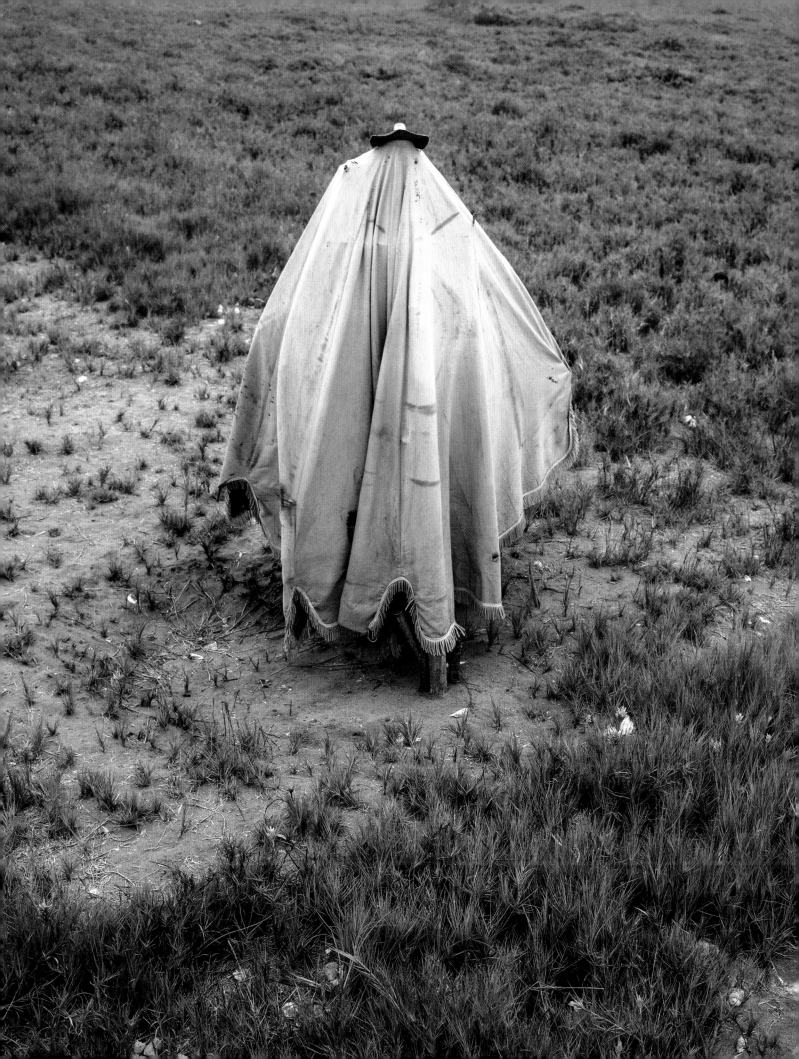

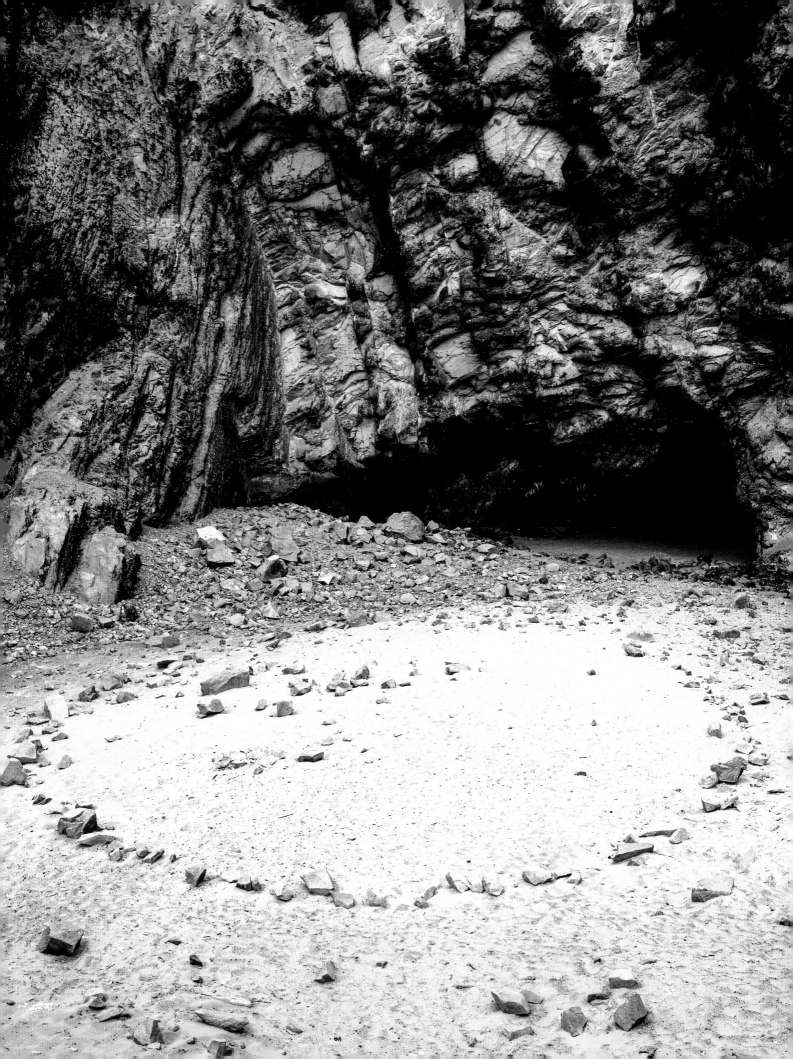

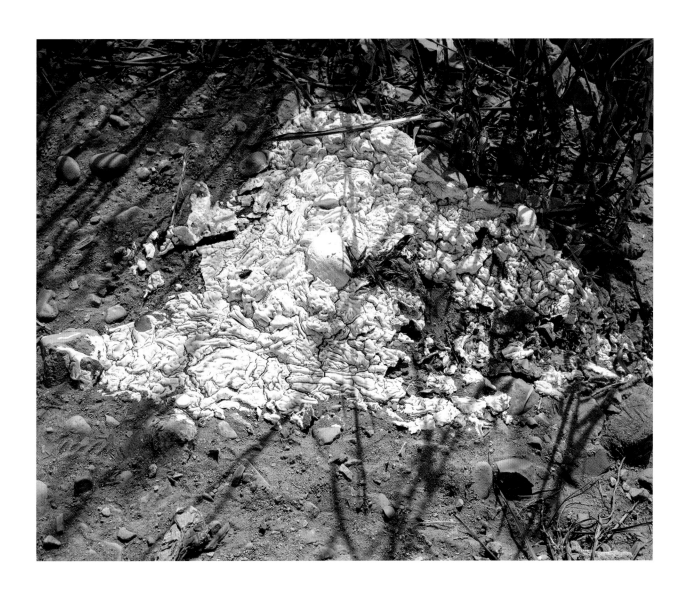

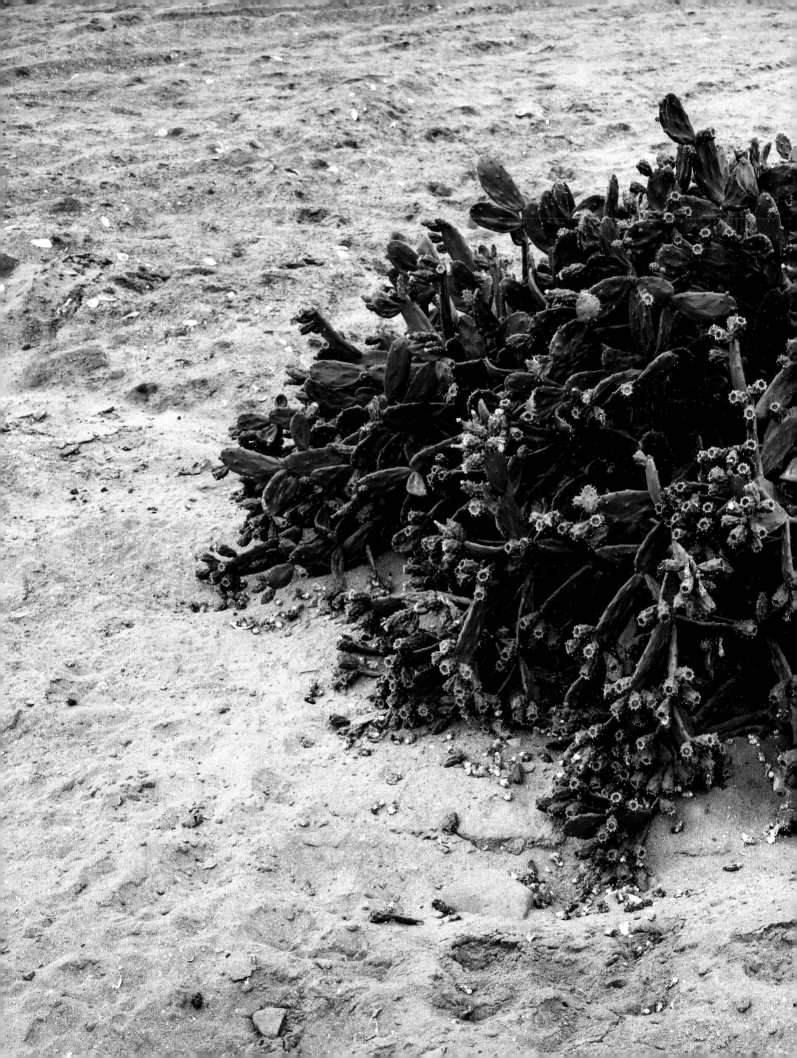

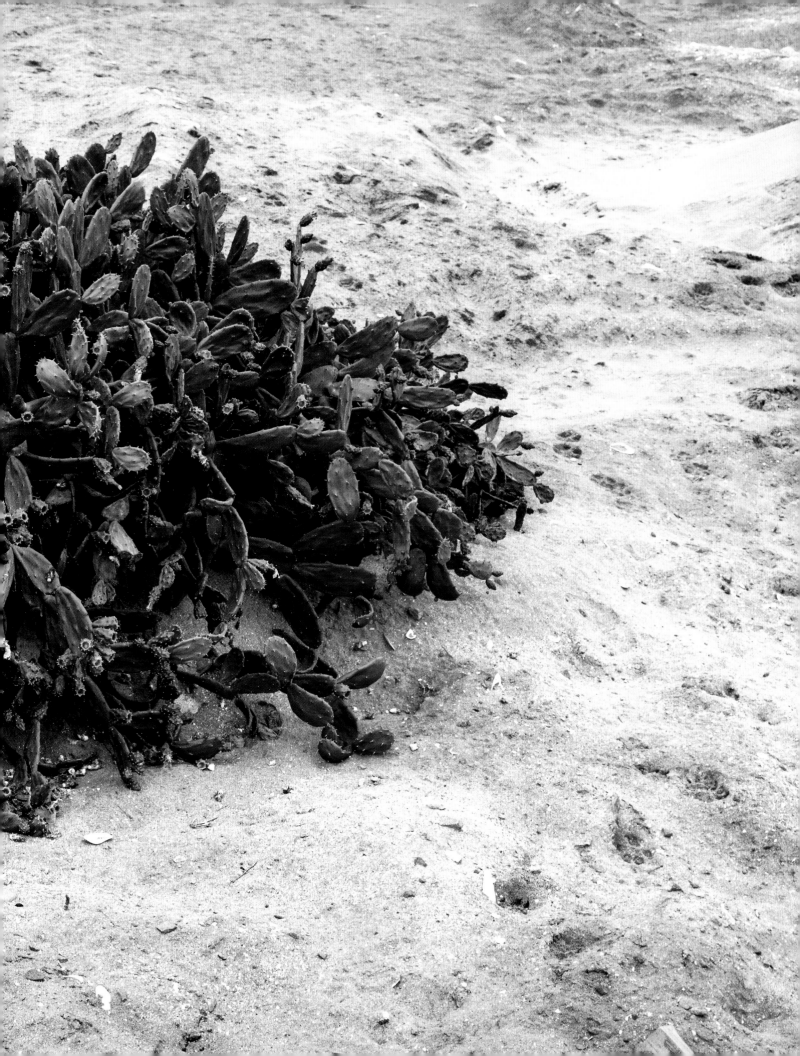

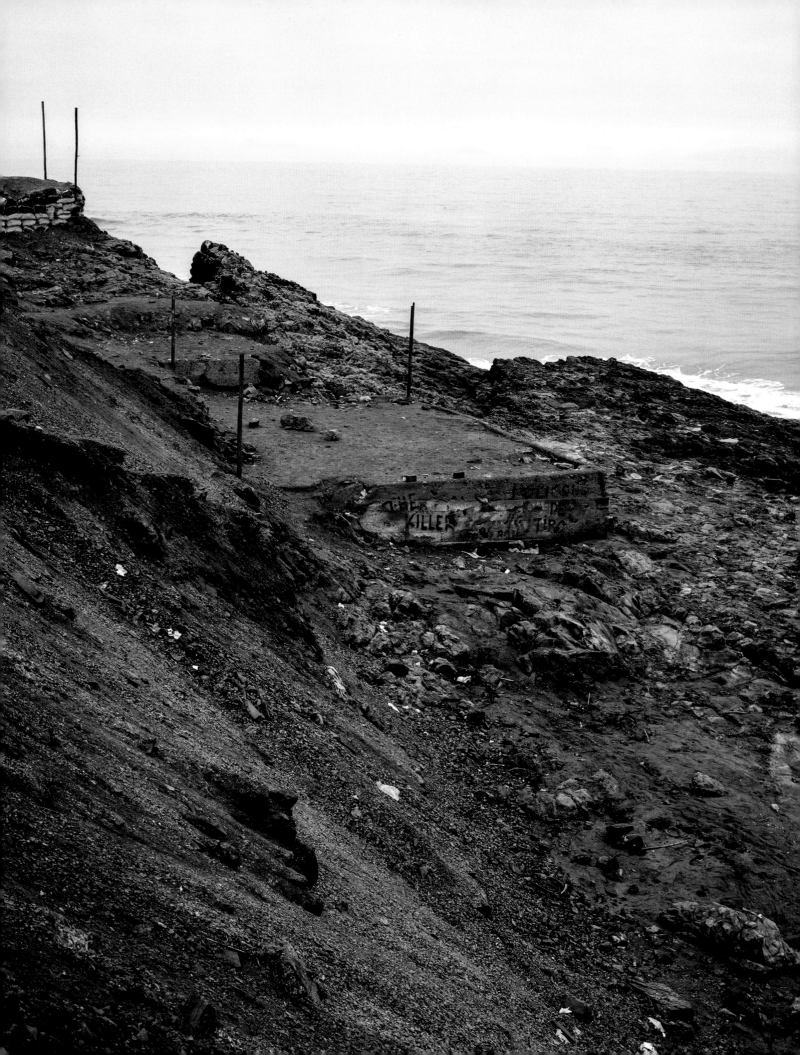

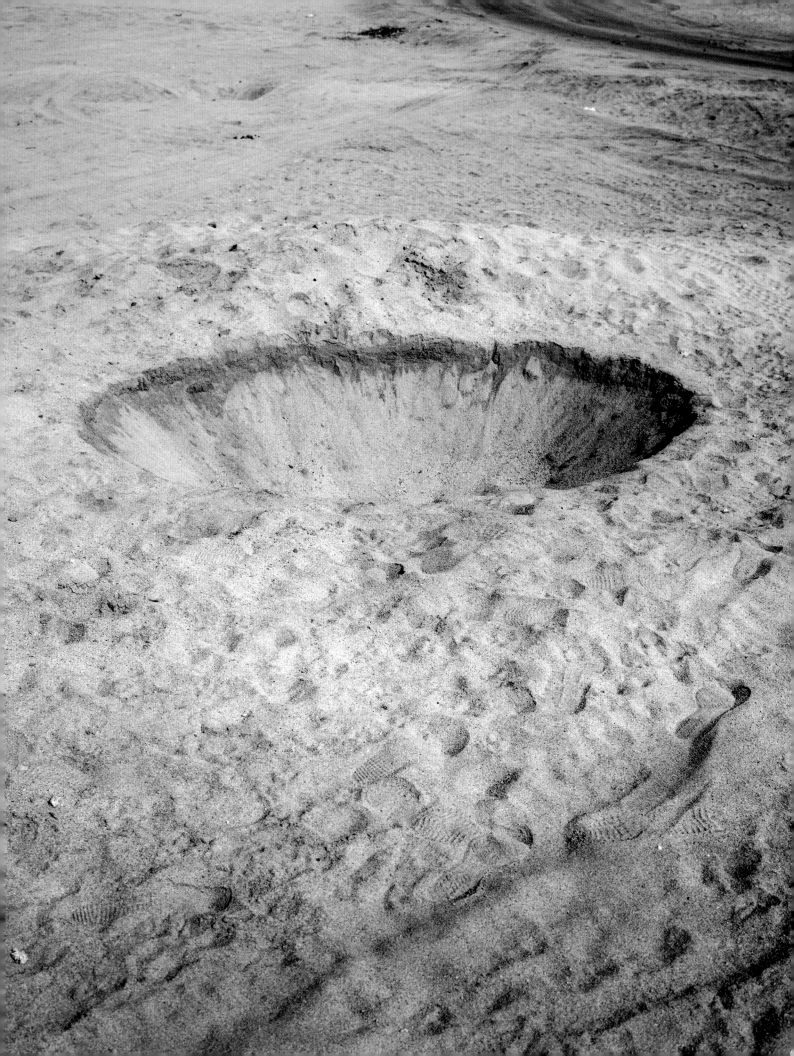

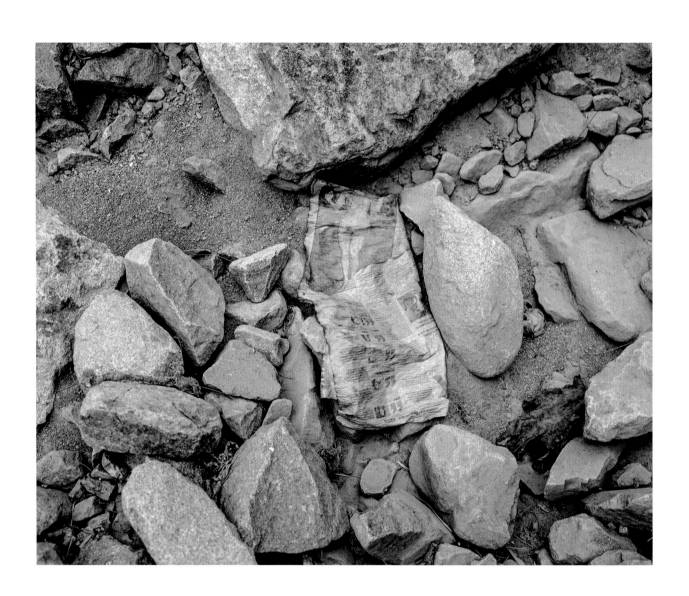

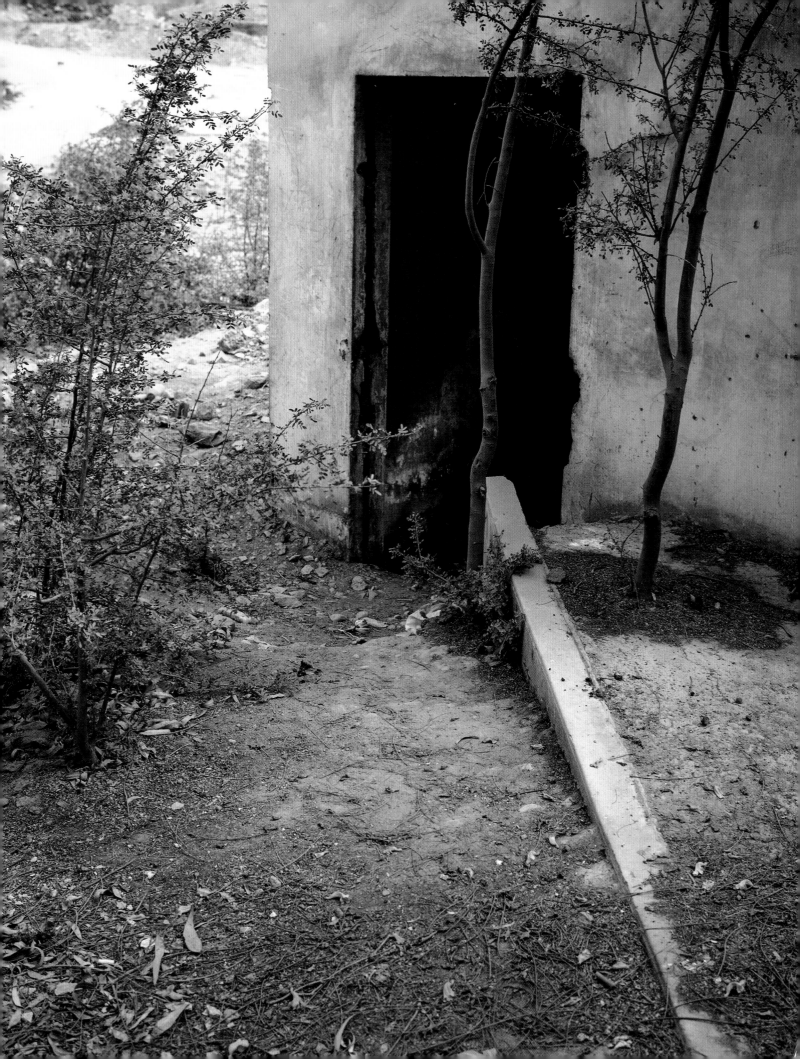

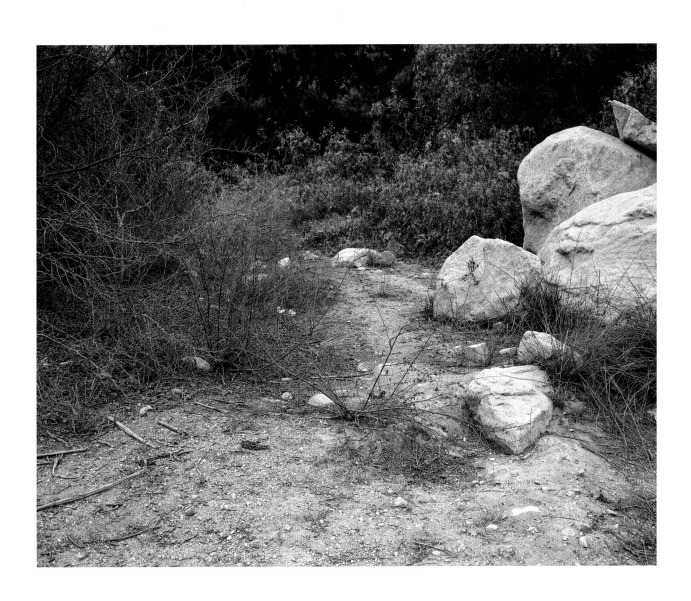

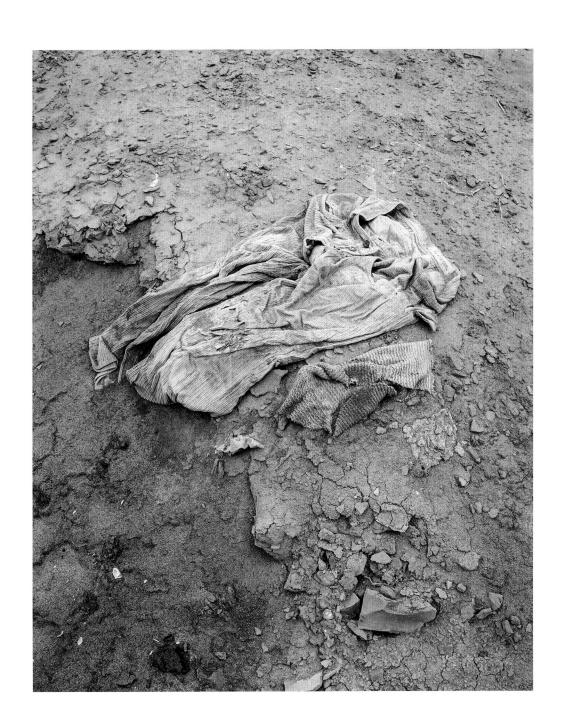

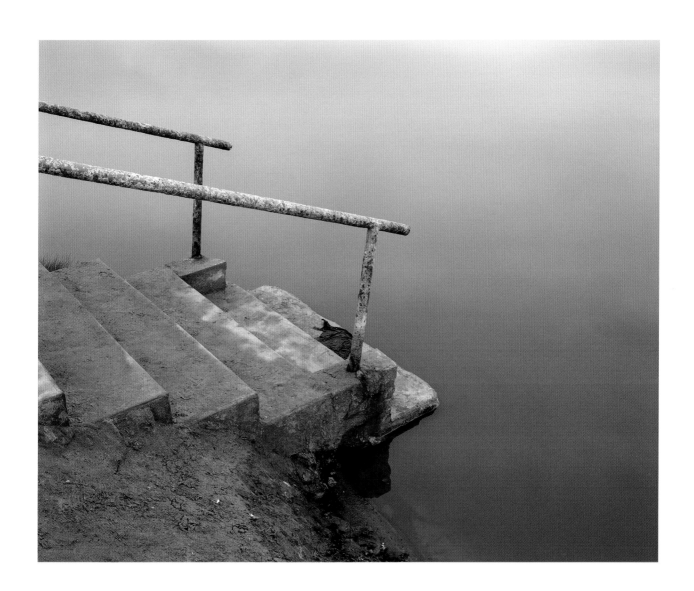

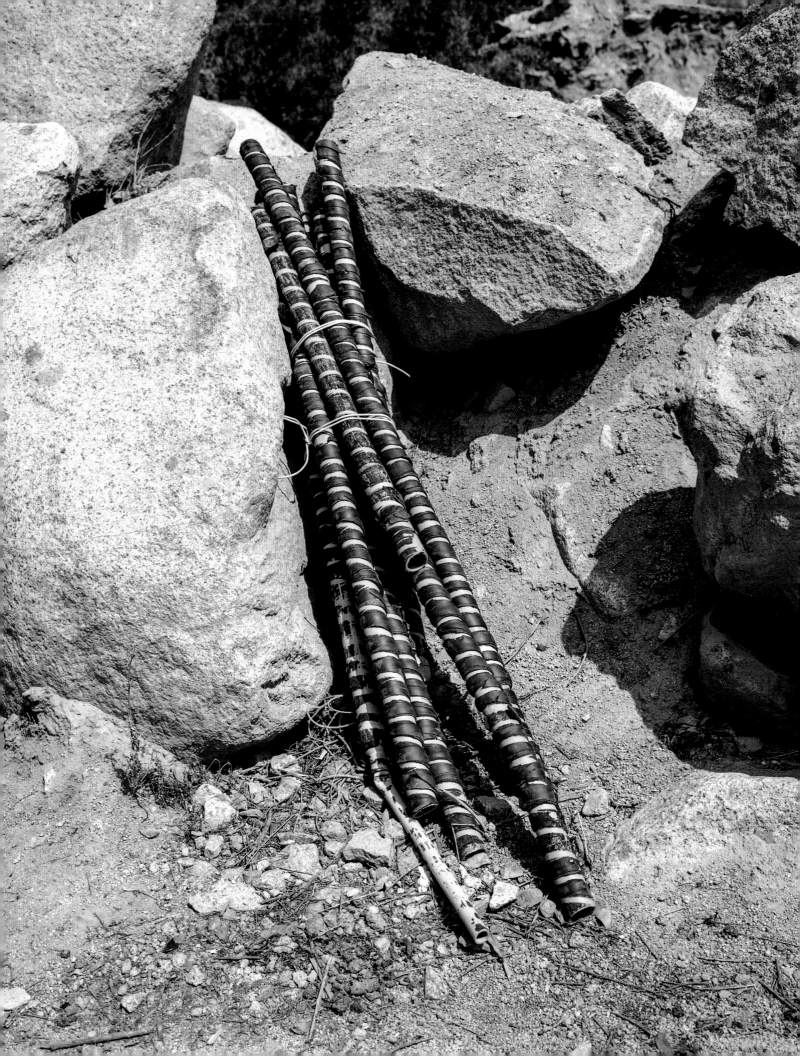

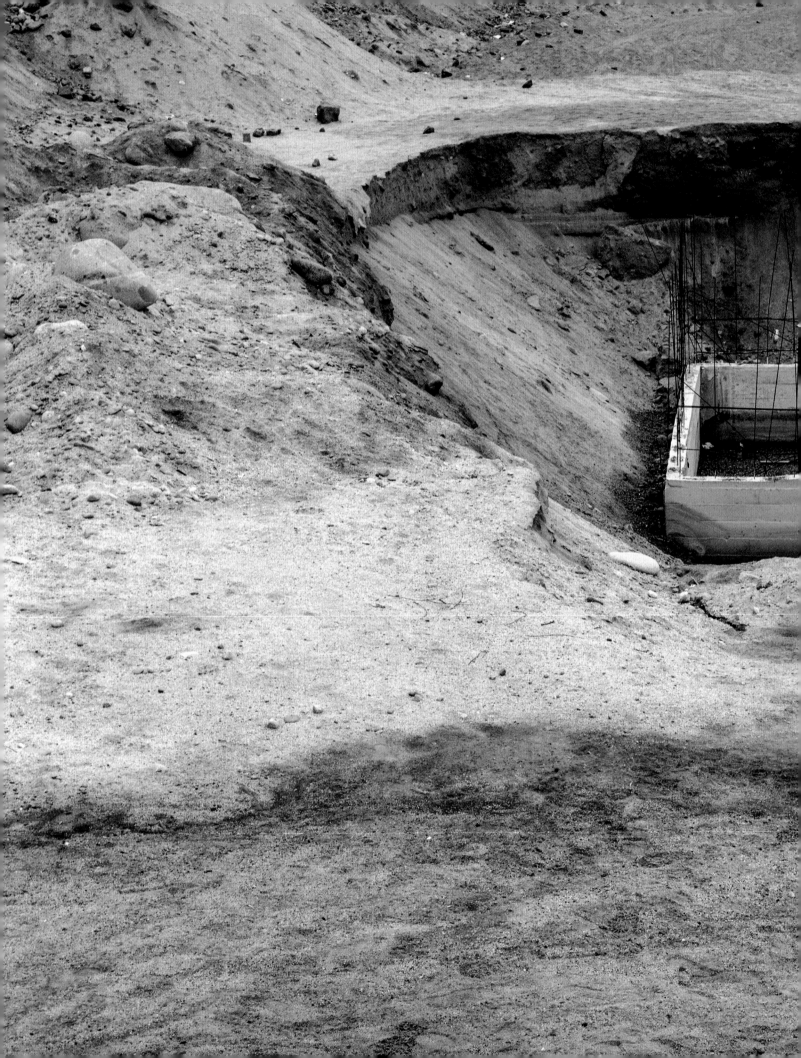

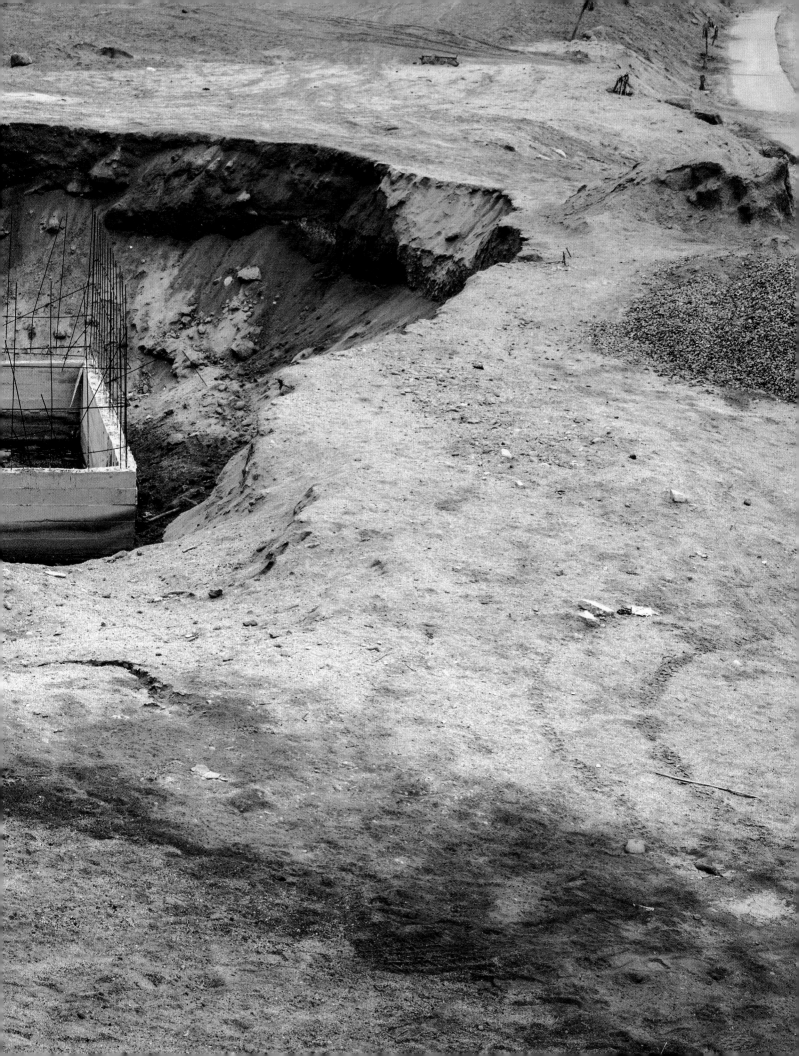

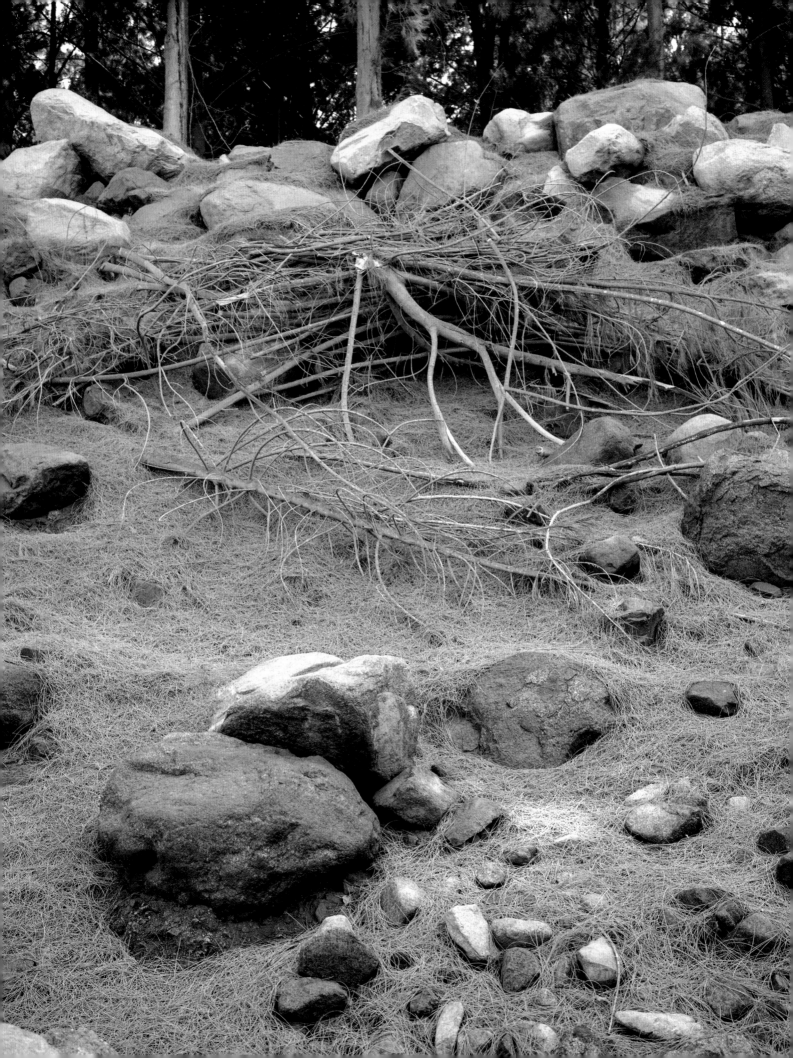

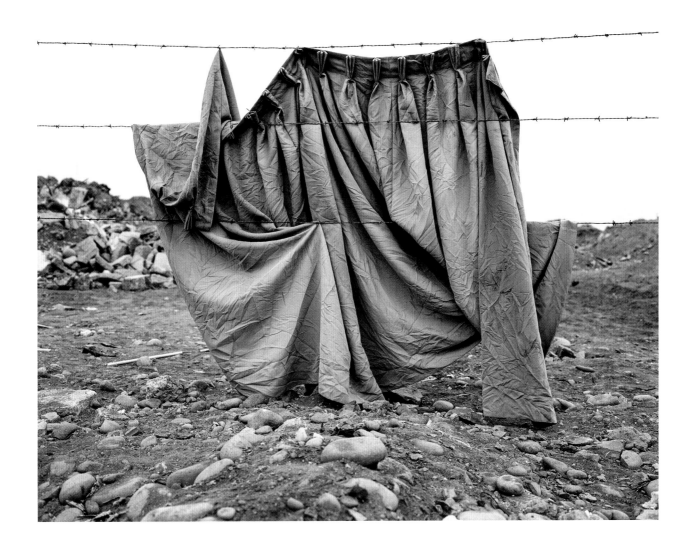

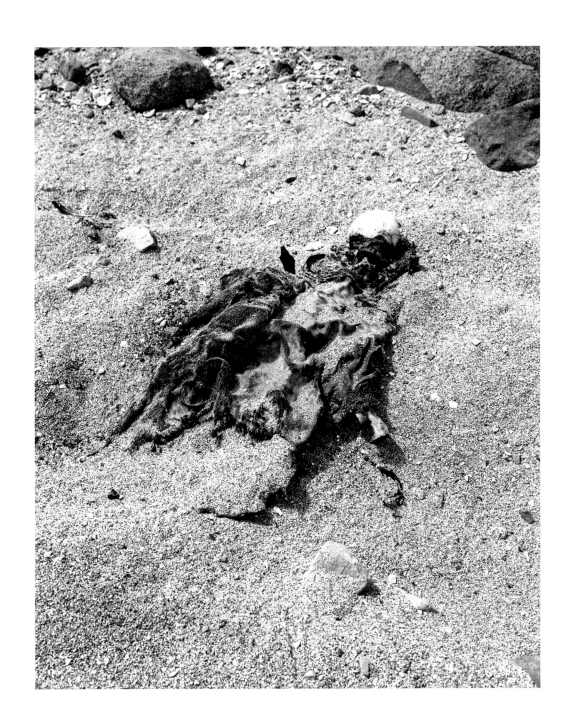

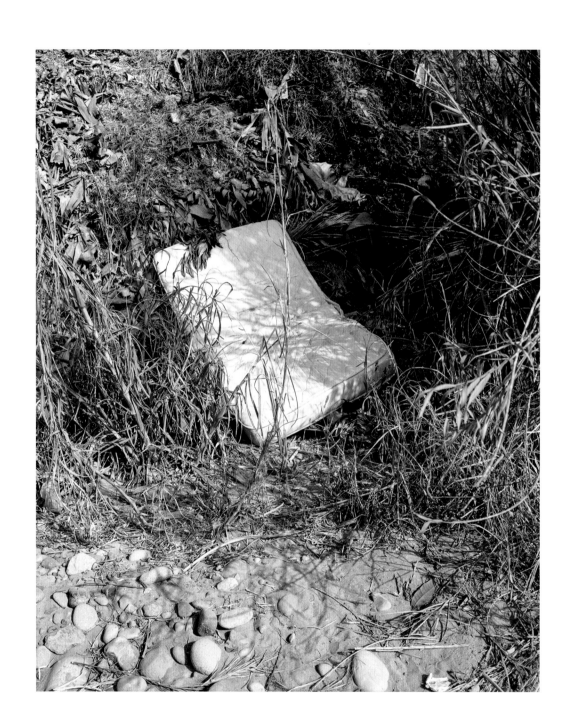

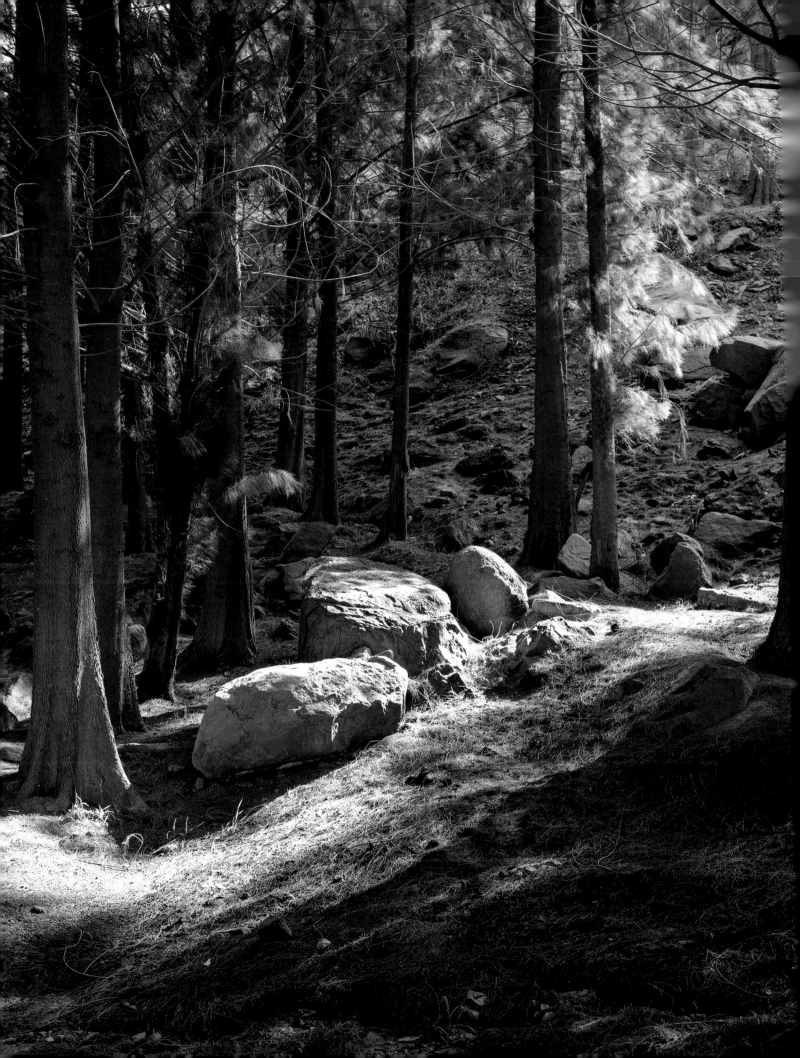

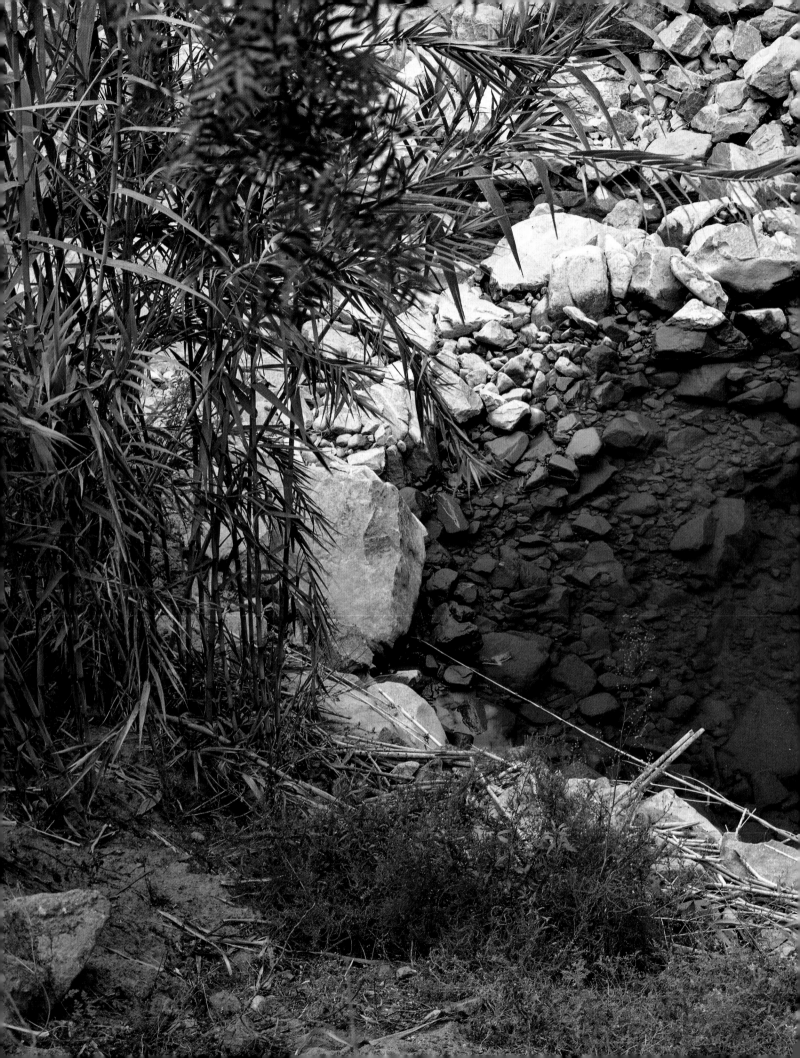

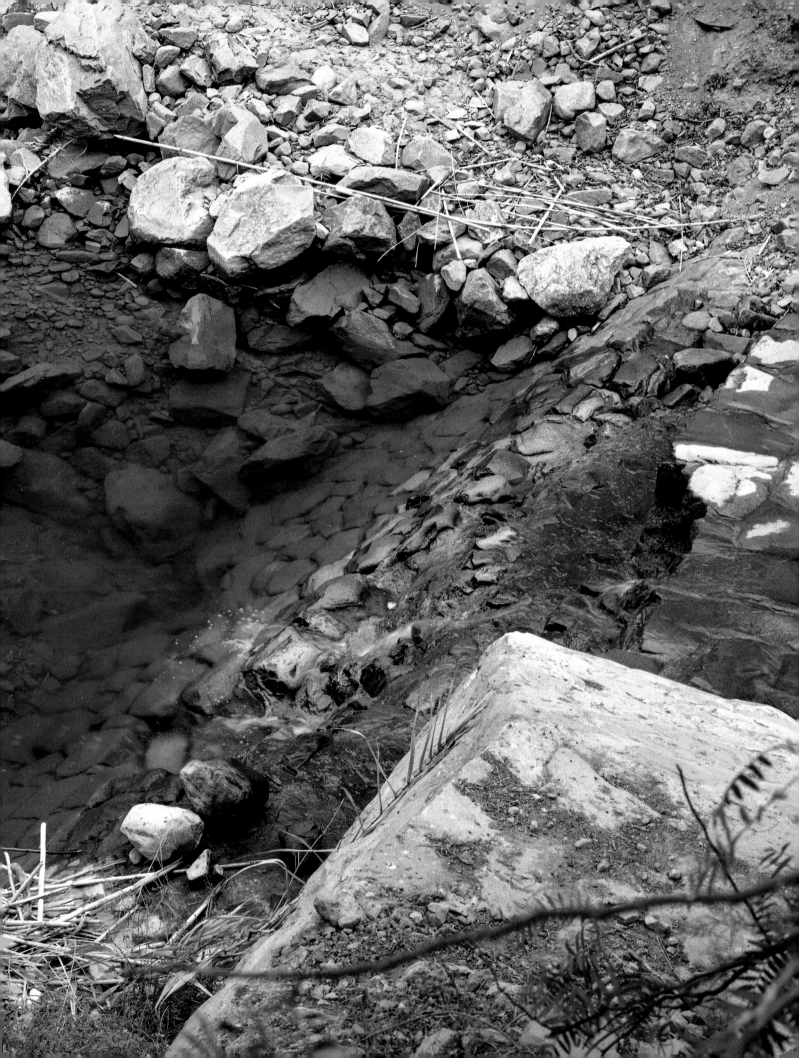

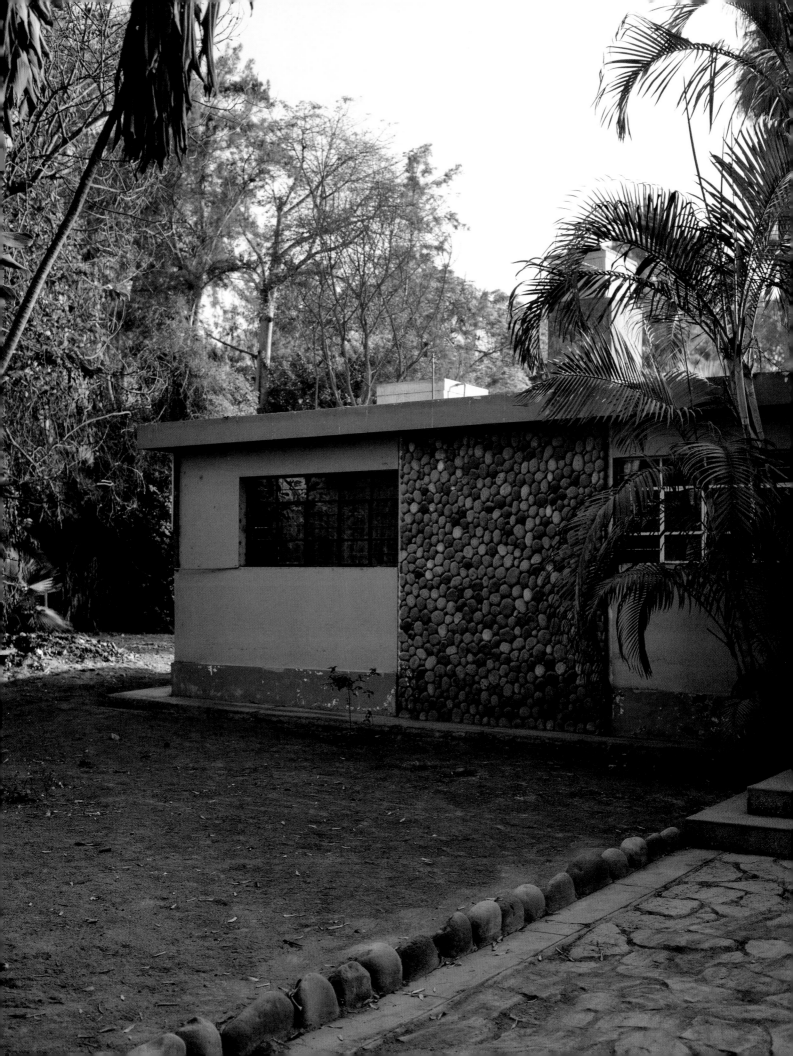

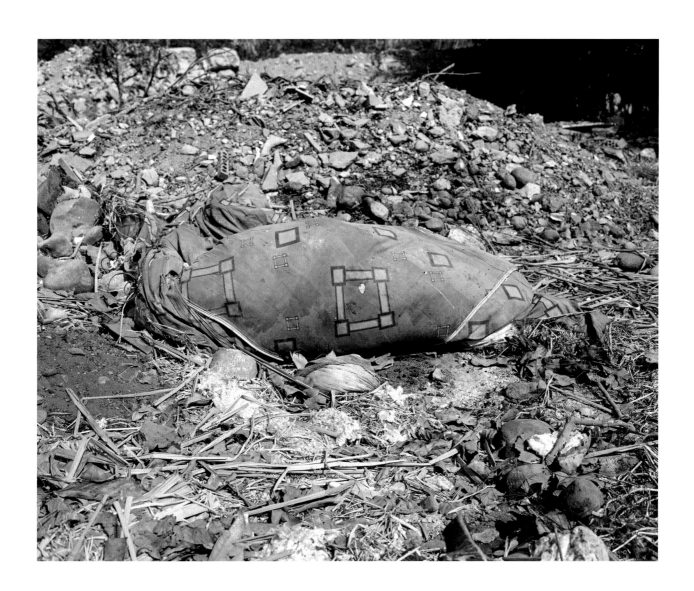

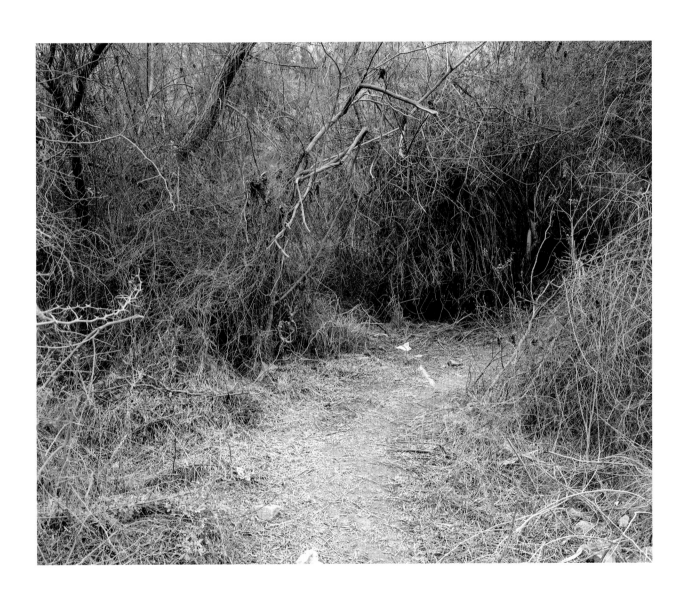

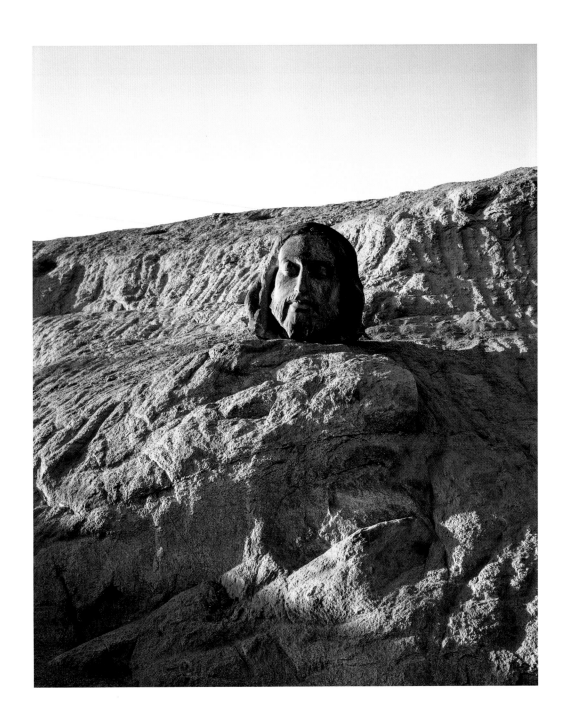

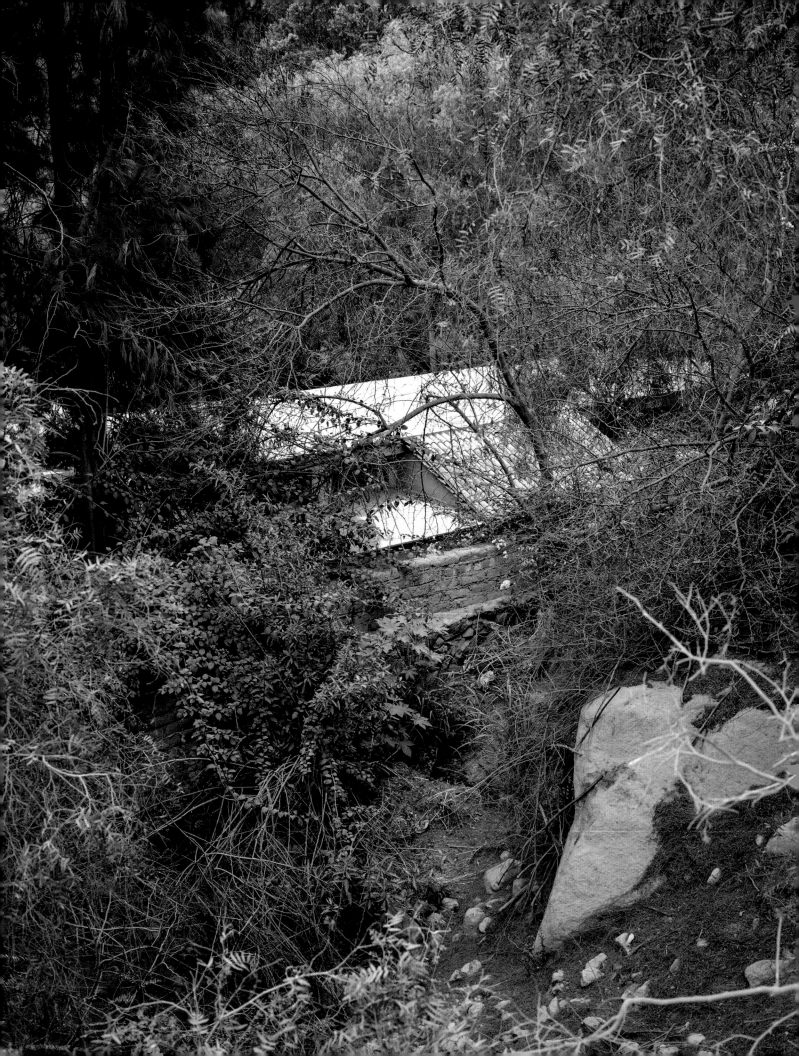

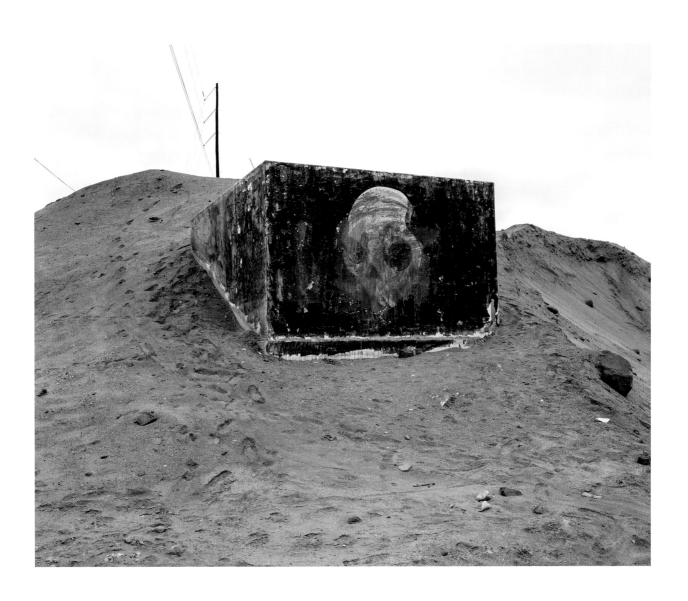

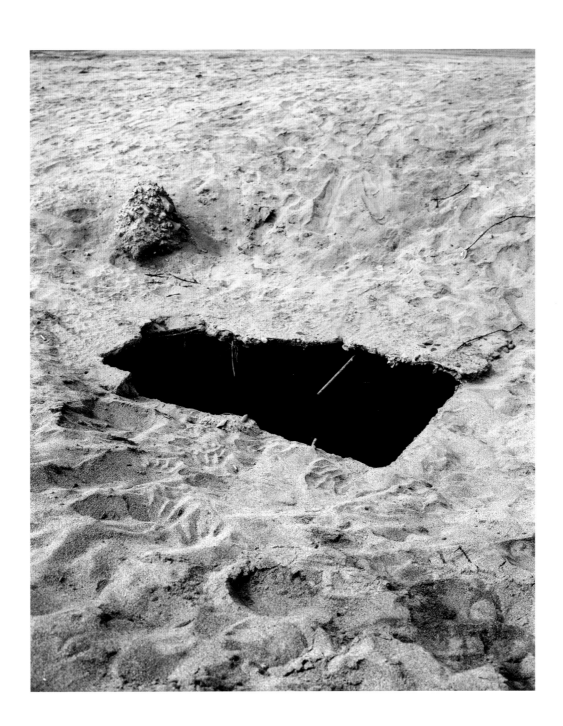

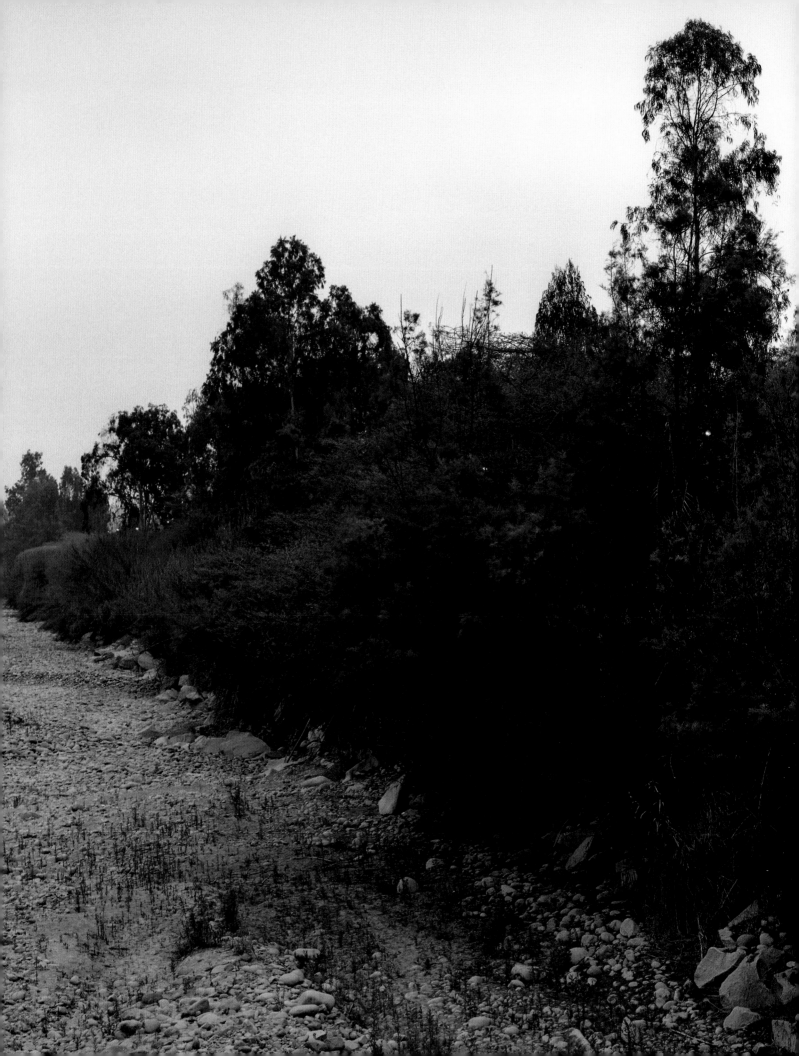

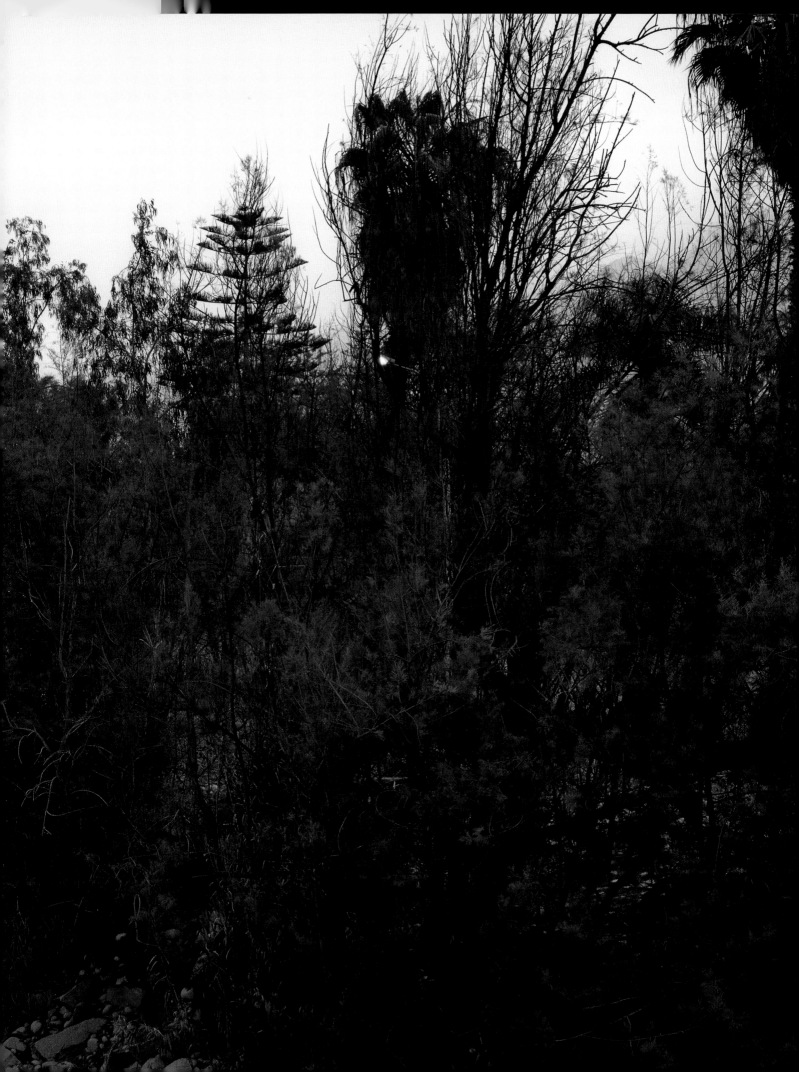

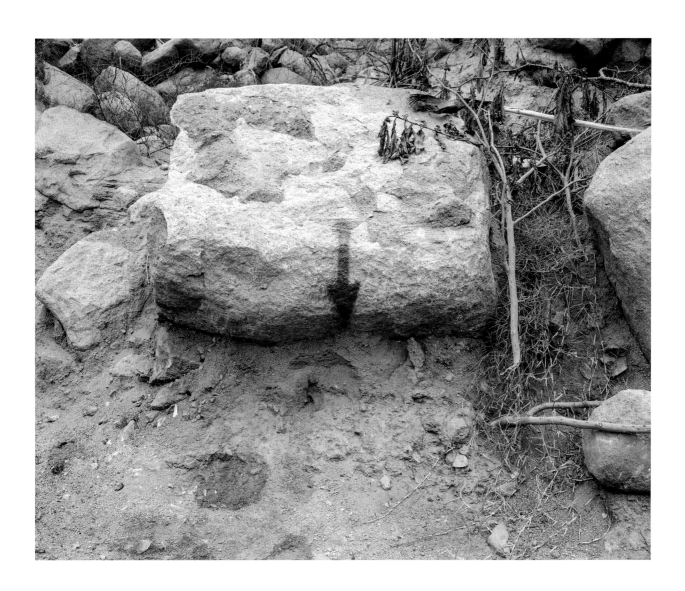

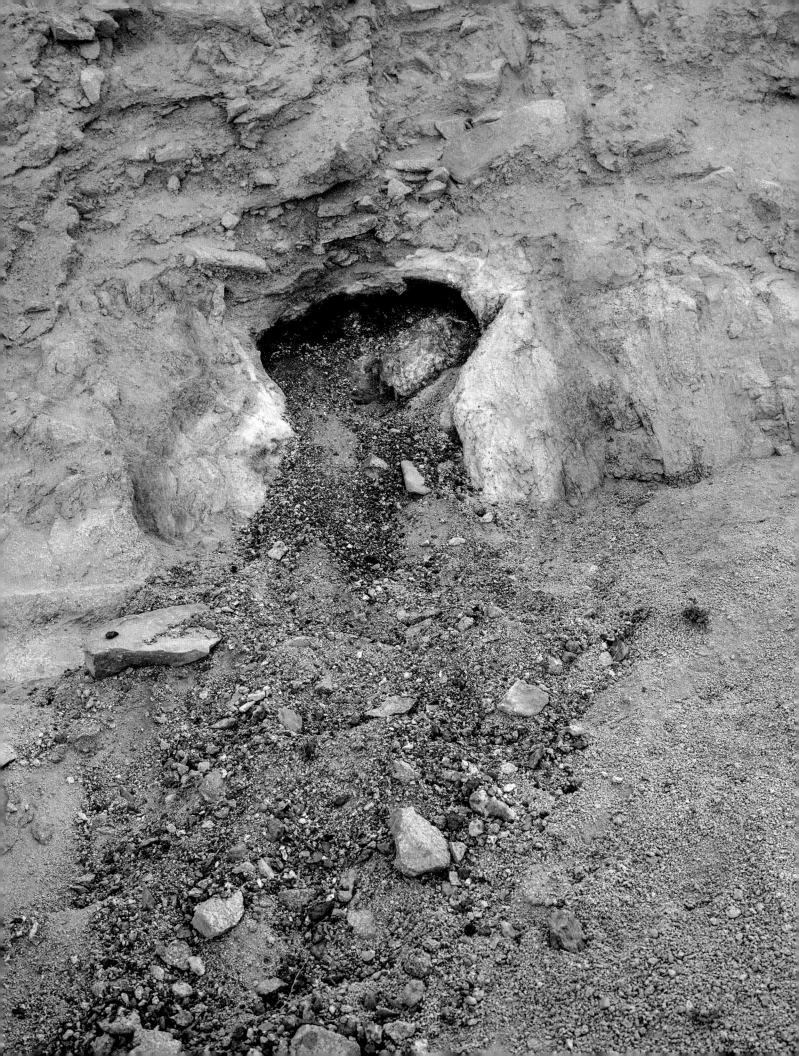

curtains
and
holes

pablo hare

The 57 photographs in *Curtains and holes*
were made between 2014 and 2017 in the Southern
and Eastern outskirts of the city of Lima, Perú

For Julia & María

Many thanks to: Mijail Mitrovic, Luz María Bedoya, Ralph Bauer,
Alexis Fabry, Olivier Andreotti, Viviana Hosaka & Mark Fisher

TOLUCA EDITIONS
© 2017
38 rue des Blancs-Manteaux
75004 Paris, France

www.tolucaeditions.com
www.tolucastudio.com

ISBN: 978-2-490161-00-3

All works by Pablo Hare
© Pablo Hare

Graphic design:
Olivier Andreotti (Toluca Studio, Paris)

Printed by Brizzolis, Madrid
October 2017

RM
© 2017
RM Verlag, S.L.
Loreto 13-15, local B
08029, Barcelona, España

© 2017
Editorial RM, S. A. de C. V.
Río Pánuco 141
Col. Cuauhtémoc 06500
México, D. F., México

info@editorialrm.com
www.editorialrm.com

#322
ISBN: 978-84-17047-36-8
DL: B 24700-2017